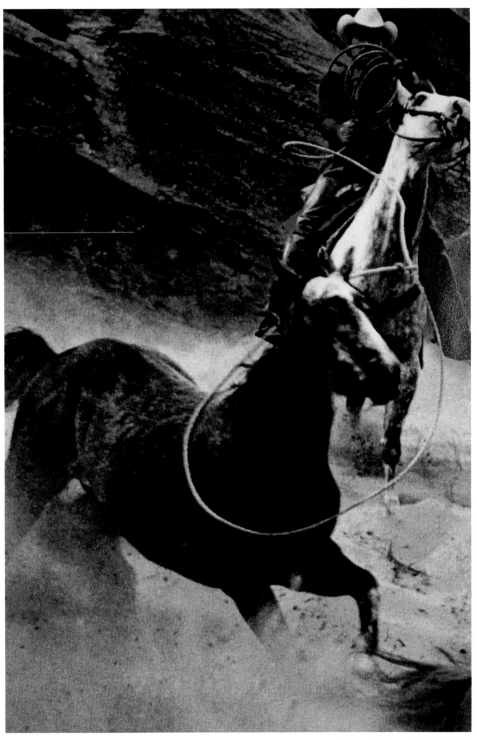

Richard Prince, Untitled, 1986

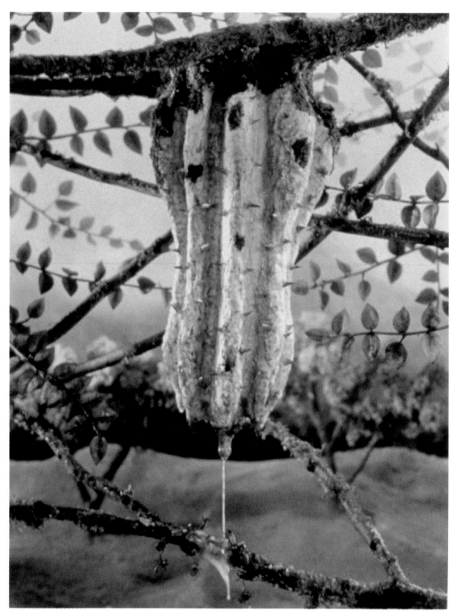

Gregory Crewdson, Untitled (Mutated Gourd), 1993

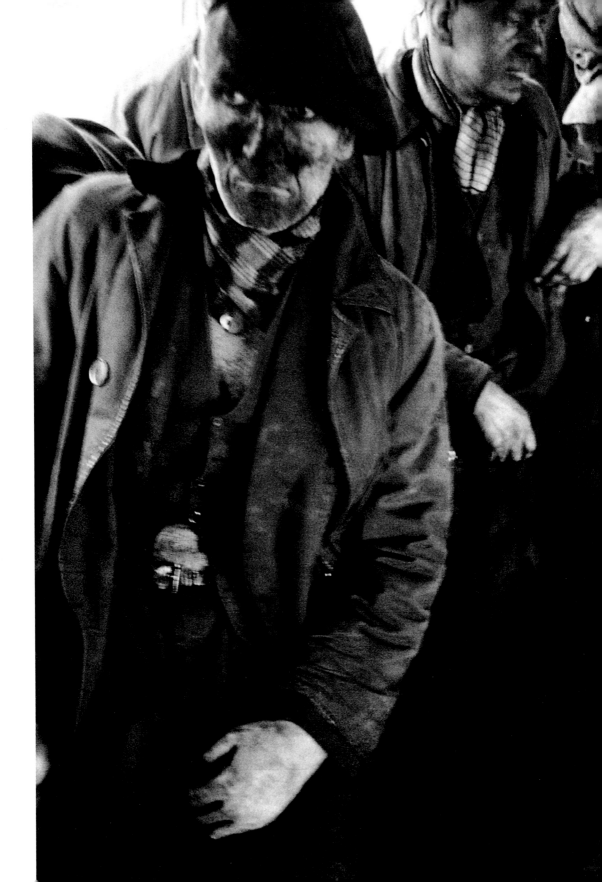

Elizabeth Janus (Ed.)

Veronica's Revenge

Contemporary Perspectives on Photography

L A C Switzerland

Edited with Marion Lambert

Scalo Zurich – Berlin – New York

Elizabeth Janus (Ed.) — Veronica's Revenge

Book concept: Marion Lambert

Cover: Robert Gober, Untitled, 1992/93

Editing: Alexis Schwarzenbach

Design: Hans Werner Holzwarth, Berlin

Scanning: Gert Schwab / Steidl, Schwab Scantechnik, Göttingen

Printing: Steidl, Göttingen

© 1998 LAC, Switzerland

© 1998 for all works the artists, for all texts the authors

Francisco Zurbaran (1598–1664),

The Veil of St. Veronica — © National Museum Stockholm

Sam Taylor-Wood — courtesy Jay Joplin, London

Gerhard Richter — courtesy Atelier Gerhard Richter

Scalo Zurich – Berlin – New York

Head Office: Weinbergstrasse 22a, CH-8001 Zurich / Switzerland,

phone 41 1 261 0910, fax 41 1 261 9262, e-mail publishers@scalo.com

Distributed in North America by D.A.P., New York City;

in Europe, Africa and Asia by Thames and Hudson, London;

in Germany, Austria and Switzerland by Scalo.

First Scalo Edition 1998

ISBN 3-931141-78-0

Printed in Germany

Contents

Nan Goldin, Philippine, Arles, 1997

To my daughter Philippine
who shared my interest in art.
M. L.

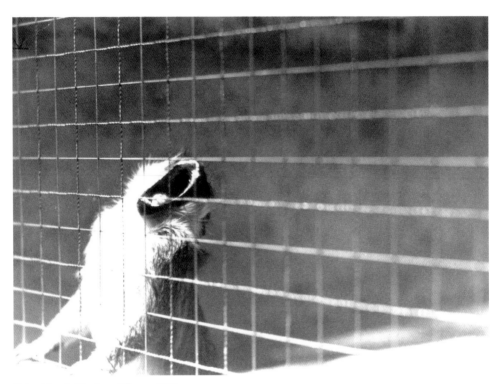

Robert Frank, Monkey at Zoo, c. 1953

Robert Frank, Valencia, 1949

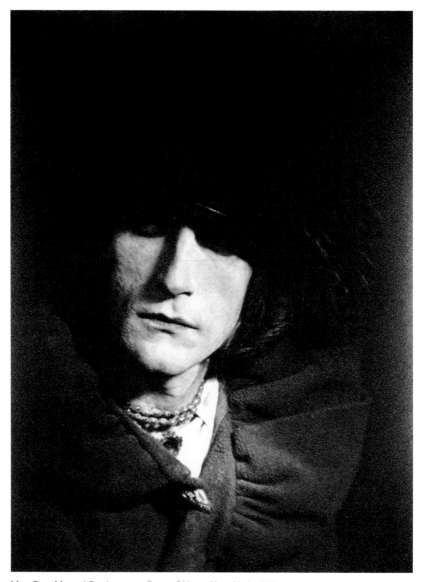

Man Ray, Marcel Duchamp as Rrose Sèlavy, New York, 1921

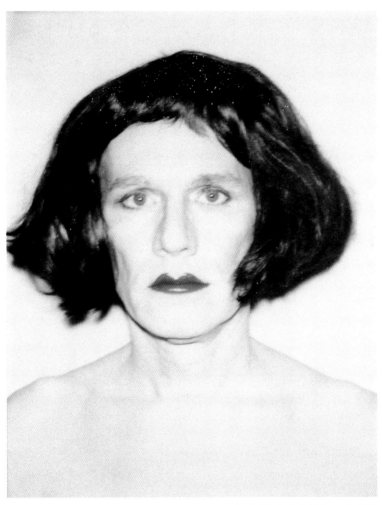

Andy Warhol, Self-Portrait, 1981

Marcel Duchamp, Elevage de poussière (Photo Man Ray), 1920

Mike Kelley, Untitled (Dust Balls), 1994

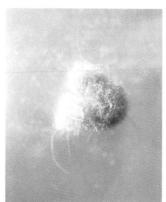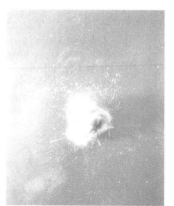

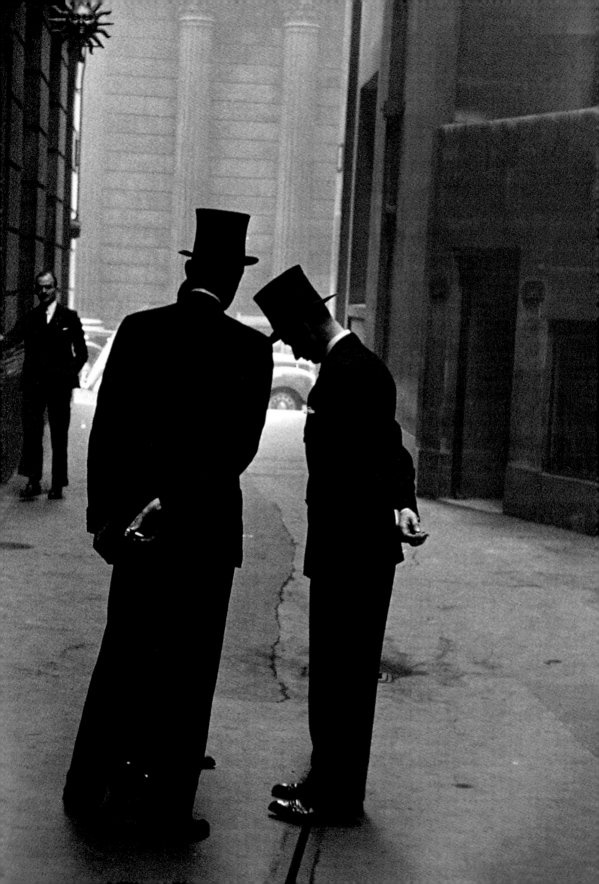

> "L'invention de la photographie a porté un coup mortel aux vieux modes d'expression, tant en peinture qu'en poésie où l'écriture automatique apparue à la fin du 19^ème siècle est une véritable photographie de la pensée."
>
> André Breton, 1921

On Revenge, Art, Artists, and Collecting

Goya is my favourite artist. His painting *Cabeza de un Perro (Head of a Dog)* found in the Black Paintings that decorated the walls of his house Quinto del Sordo, sums up my understanding of the meaning of art. This dog, struggling against all odds, looks to the right — to the future — barely keeping his head above the sand, and thus symbolises a struggle for life, in spite of emptiness, humiliation, sadness and age. The image reduces the human condition to the solitude which is essentially ours, using light and an almost empty canvas.

The moral victory of those who sacrifice their lives for justice is the message of the painting *Third of May, 1808.* And the representation of the mentally ill, or the destructive forces that devour their children (in a political sense), illustrate the painter's concern for the outcast and the underdog, those who are politically, mentally, or materially outside of the mainstream.

Leaving the Prado, I rummaged through the stands on the desk for the image of my favourite dog and by chance found a postcard of Zubaran's *Veronica.*

The story of Veronica, whose real name was Berenice, is well-known: She was the woman who wiped Christ's brow on the way to Calvary with a cloth that miraculously retained the image of His face and illustrated

Robert Frank, London Bankers, 1951

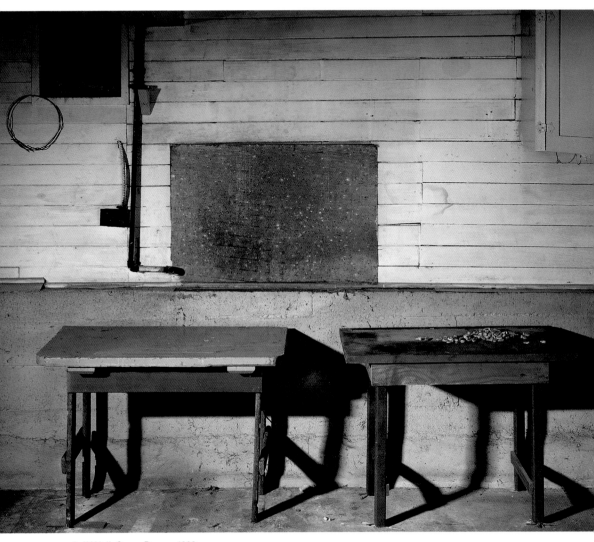

Jeff Wall, Some Beans, 1990

His suffering. A photograph. The first. An image of compassion. A document of suffering and a permanent testimony to sacrifice for faith.

I came of age at a time when photography was mainly documentary, the time of *Magnum*, *Life*, images of war, injustice, racial strife. Then there was the discovery of Diane Arbus, whose identification with people living outside accepted norms ended so sadly. And, most of all, my real love, Robert Frank. The condition of mankind, without embellishments, without artifice. And a quest for answers, for meaning.

From the day of its invention in the 19th century, photography closely followed painting — a passive reflection without any inspiration, "the scrupulous imitation of nature" (Coubert, commenting on the art of painting) and a representation of reality.

Painting was the privilege of the rich and powerful and maybe to depict the world is a way to control it. Art, after all, has been subsequently an expression of religion, of the power of the aristocracy and the bourgeoisie and has become, after Pop art, much more of a phenomenon of mass culture.

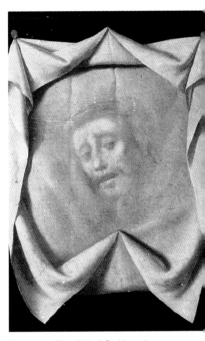

Zurbaran, The Veil of St. Veronica
National Museum, Stockholm

Contemporary art, and particularly today, is the expression of the preoccupations, sufferings and political convictions of others. It is about meaning and content, not about representing reality.

The use of photography in contemporary art is the result of two converging components: its familiarity to us as a visual language because of the world of images we live in, and its past use to document.

Most contemporary artists use the medium of photography because it is a language of our time. As Cindy Sherman says: "I love my camera — it is like a paintbrush."

Artists are outsiders by choice and by definition, and they break into territories and transgress boundaries. They are controversial by definition, because they challenge the established norms and values. Personally, I oppose the tendency of our society to sweep under the carpet vital and actual questions regarding sexuality, identity, feminism and the alienation of human beings in an industrialized world. Contemporary artists, like naughty children, point to what we do not wish to see. And, for me, the intrinsic value of contemporary art lies there.

The revenge of my friend Veronica is that she returned, with force, to analyze our society. And she devotes all of her intelligence and knowledge, in the widest philosophical sense, to do so.

The status of "collector" is an indifferent one to me, and in fact, fills me with horror. It means cocktail parties and openings, and outdoing the "Joneses."

Collecting art would be meaningless hoarding if the collector were not sustained by the idea that he or she is only the transitory custodian of treasures. I have always considered it my duty to share it with others. The understanding of the ideas that preoccupy the artists today, the ideas and the way they are expressed by them, have taught me how to see and enriched my life in more than one way.

Ultimately, my gratitude goes to the artists.
Marion Lambert

Rosemarie Trockel, Friend from Naples, 1994

Rosemarie Trockel, Eliana, 1993

Rosemarie Trockel, Mela, 1993

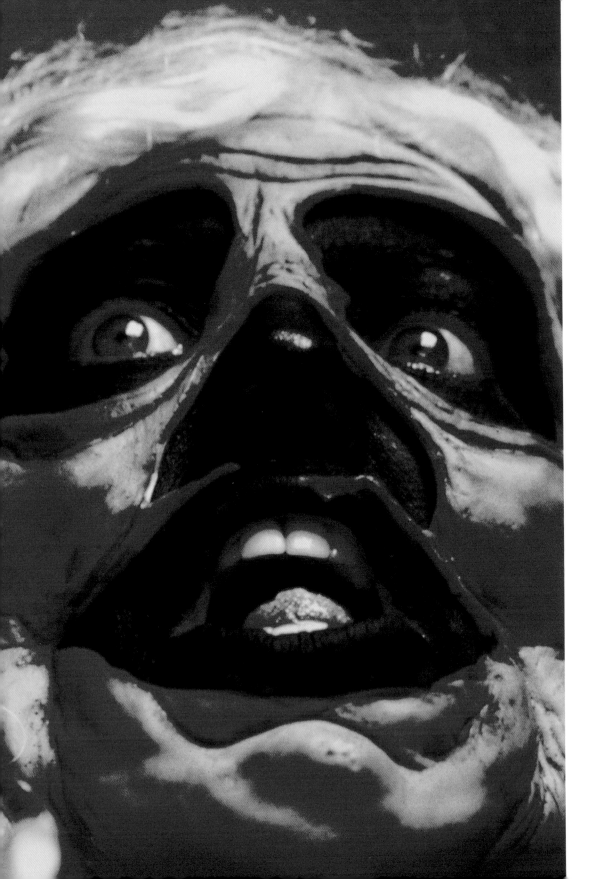

Elizabeth Janus

Introduction

"You know exactly what I think of photography. I would like to see it make people despise painting until something else will make photography unbearable."

Marcel Duchamp in a letter to Alfred Stieglitz[1]

Photography has held an important, if often inconspicuous, position within the history of art. Since its invention, it has struggled for recognition as a legitimate art form, gradually transforming its essential function, that of depicting the "real," into one that, following the precepts of traditional pictorial art, came to represent accepted aesthetic ideals. This co-optation of both the formal qualities of painting (framing, perspective, composition) and its subjects (landscapes, portraits, genre scenes), raised photography into the realm of the fine arts but without ever really challenging painting's supremacy. At the same time, photography has been key to some of the most radical artistic advances, partly because it forced artists to ask profound questions about the roots of representation and partly because it changed the way we think about and look at the world around us.

Since the 1960s and the advent of conceptual art, photography has been taken up by more and more artists who, though often trained as painters or sculptors, found in it a greater potential for experimentation and exploration as well as a means of looking critically at artistic conventions. Resuscitating some of its more radical uses by Surrealist, Dada and Bauhaus precursors, many artists now use photography in increasingly

Cindy Sherman, Untitled # 319, 1996

inventive ways, whether as a critique of the culture industry itself or as a challenge to traditional ideas about esthetics. Among the most influential sources for artists, especially at the end of the 1970s and throughout the 1980s, have been the conceptual pioneer, Marcel Duchamp, the political montages of John Heartfield and Hannah Höch, the Pop strategies of Andy Warhol, and Walter Benjamin's ideas about art and originality.

It is the transformation of art photography during the past thirty years that is the focus of *Veronica's Revenge: Contemporary Perspectives on Photography.* The intention was to bring together an array of artists, writers, historians, critics and curators, all of whom are implicated in the evolving understanding of what defines photography as art, and to have them re-flect on the present state of the medium. In many instances this has meant looking at its position within the larger context of contemporary art and visual culture, and in others it has meant focusing on its use by specific artists in an attempt to understand the reasons why it has become, in recent years, one of the most prevalent means of artistic creation.

The inspiration for many of the thoughts in the following essays can be found in texts on photography and its function in society by John Berger, Roland Barthes and Susan Sontag as well as the writings of Douglas Crimp, who during the early 1980s attempted to analyze the ways in which photography had suddenly become the tool *par excellence* of post-modern art practice. But the main point of departure for this book is a reflection on a specific ensemble of more than 300 photographic works, the core of which were made during the 1980s by American and European artists, that make up the Lambert Art Collection.

In situating it in recent art history, Jeff Wall gives an overview of photography within the context of modernism and avant-garde progression. He follows its changes during one of its most crucial phases — that of the move from pictorialism to idea-based image-making — and traces the histo-rical roots of conceptual art's important influence on the medium, particu-larly the "amateurization" of photography, a point that is picked up by

> Some of the most important changes in our understanding
> of photography within the context of art have been
> brought about by political and social upheaval, as is the
> case with feminism.

Neville Wakefield in his discussion of the medium's eschewing of specta-
cularization and the sublime in favor of the banal, or what he has called
"the aesthetic of disappointment".

The attack on photography's technical and formal canons has pro-
duced heated animosity in established photography circles and nowhere is
this more evident than in the museum. Both Hripsimé Visser, who is directly
implicated in caring for and forming the photography collection of the
Stedelijk Museum in Amsterdam, and Andy Grundberg, whose writings for
the *New York Times*, among other publications, have closely followed one
of its most critical periods of development—the 1980s—address in their
essays some of the problems faced by museums which are in the process
of redefining the criteria by which photographs are judged and collected.
A more historical perspective is found in Holger Liebs's first essay, which
traces contemporary German photography back to its roots in 1920s "Neue
Sachlichkeit" and the conceptual rupture brought about by the work of
Bernd and Hilla Becher, who have influenced a whole new generation of
artists in Germany.

Some of the most important changes in our understanding of
photography within the context of art have been brought about by political
and social upheaval, as is the case with feminism, which Laura Cottingham
discusses in her essay about the performative base of many photographs
taken by women during second-wave feminism in the 1970s. This unde-
niable influence is also discussed in relation to the exclusion from main-
stream critical discourse of women painters and sculptors, thus making

photography a medium of choice, one might even say of protest, for many female artists.

The inestimable effects on photography of such time-based media as television, film, and video are considered by Richard Flood, Jeff Rian and Holger Liebs in his second essay. They raise questions about its relationship to memory, communication, contemporary mythology and ways of seeing — issues that have been pertinent for the generation of artists whose experience has been significantly affected by the omniprescence of technological media.

Photography's position within the larger context of other artistic practices is addressed by Marina Warner and Jennifer Blessing, who discuss the medium in relation to religious mysticism, fetishism, abjection, and the changing perception, through an alteration of context, of the sacred and profane. While Warner touches on the "daring" associated with avant-garde advances and the reception of the "monstrous" and the "grotesque" as characteristics of the magic and the spectacular that are expected from art, Jennifer Blessing, who takes a position that is half-Bataillean, half-Barthean, suggests that photographs have come to replace religious relics and other sacred talismans as pseudo-sacred objects or, what Barthes has called, living signs of Death.

The theme of transgression is taken up by Stuart Morgan, who writes on the work of Damien Hirst and several other British artists who have recently taken the art world by storm, situating their often aggressive tactics within the context of earlier "bad boy" artists, Gilbert & George. And finally, Bice Curiger takes as her point of departure the dissolution of boundaries between various media, particularly painting and photography, and what this has meant in formal terms but also in a greater understanding of what constitutes artistic expression.

The title *Veronica's Revenge: Contemporary Perspectives on Photography*, which was suggested by Marion Lambert, is intended to evoke the earliest account of image-transfer — that of Saint Veronica's veil which,

Robert Gober, Untitled, 1992/93

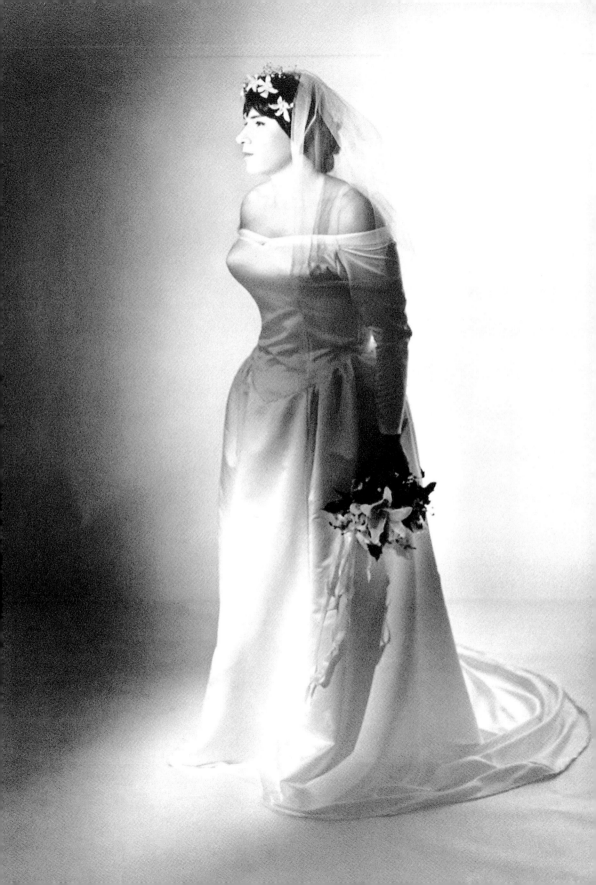

Vatican Condones Discrimination Against Homosexuals

By PETER STEINFELS

A Vatican office has urged Roman Catholic bishops in the United States to scrutinize laws intended to protect homosexuals and to oppose them if they promote public acceptance of homosexual conduct.

There are areas in which it is no unjust discrimination to take sexual orientation into account," the Vatican's Congregation for the Doctrine of the Faith, which enforces matters of doctrine for the church, said in a statement sent last month to American bishops. It specified adoptions, placement of children in foster care, military

service and employment of teachers and athletic coaches.

The statement was given to news organizations this week by New Ways Ministry, a Catholic gay-rights group with headquarters in Mount Rainier, Md., and was first reported by The Washington Post yesterday. The minority called the statement an "embarrassment" and "evidence of a growing and serious gap between the Vatican and Catholics.

Unusually Detailed

But the statement's focus on specific legislation was unusual.

"Previous documents have brought

Concern that gay rights threaten marriage.

up the question of legislation," said Archbishop Rembert G. Weakland of Milwaukee, "but this is the first time I have seen anything so detailed."

Vatican statements normally prescribe general moral principles and leave their legal applications to the local bishops.

The American bishops have taken a variety of stances toward statutes barring discrimination on grounds of sexual orientation.

Echoes 1986 Statement

The Vatican statement repeated the Vatican officer's 1986 description of homosexuality as "not a sin" but "a more or less strong tendency" and "an inclination" that "must be seen as an objective disorder"

This language, the statement said, was meant to counter "an overly benign interpretation" of homosexual orientation, the statement said.

In its own statement, New Ways Ministry said that the Vatican's defense of discrimination in areas like adoption, foster care, military service and employment of teachers and coaches rested on "blatant stereotypes.

The group also cited a May 1992 Gallup poll showing that 78 percent of American Catholics support equal rights in employment for homosexual people.

**SUMMER IS FOR CHILDREN:
GIVE TO THE FRESH AIR FUND**

Youth Worker Held In Death of Son, 9

WOODBURY, N.J., May 16 (AP) — A state youth worker has been charged with murder in the death of her 8-year-old adopted son, the authorities said. She was accused of beating him with a 30-inch piece of bannister.

The woman, has been held in Gloucester County Jail since she took the child, early Thursday morning.

Mrs. Prince, of Monroe Township, told the authorities that she was punishing the boy, who was adopted when he was 3.

The boy was airlifted to Children's Hospital in Philadelphia, where he died.

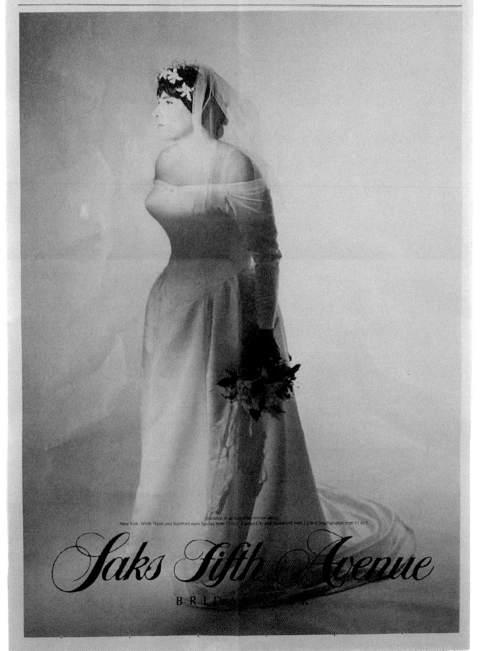

used to wipe the brow of Christ on the way to Calvary, miraculously re-
tained his image. As a metaphor for the photographic process itself, the
idea of the *vera icon* also points to the surprising evolution of photography
in recent years, during which it has moved from its beginnings as a tech-
nical means of reproducing the real to its current status as a primary sup-
port for much of the most significant art being made today, a remarkable
transformation that attests to its inestimable contribution to the history
of art.

[1] Quoted in Douglas Crimp, "The End of Painting," in *October*, no. 16, Spring 1981, p. 75.

obert Gober, Untitled, 1992/96

Nan Goldin, 10 Downing Street, 1994

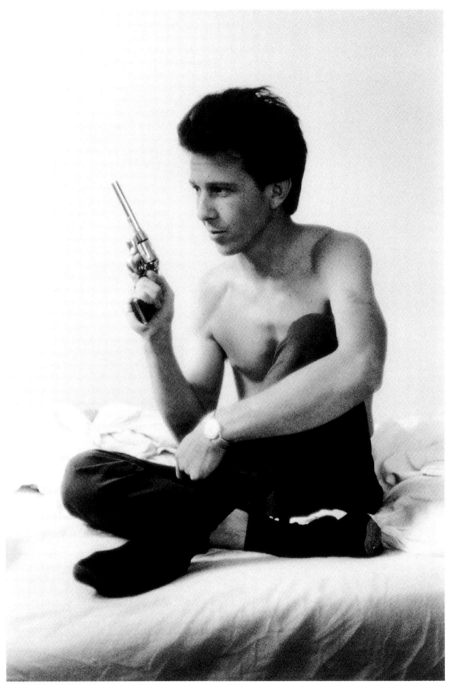

Larry Clark, Tulsa 1968 –71, 1972

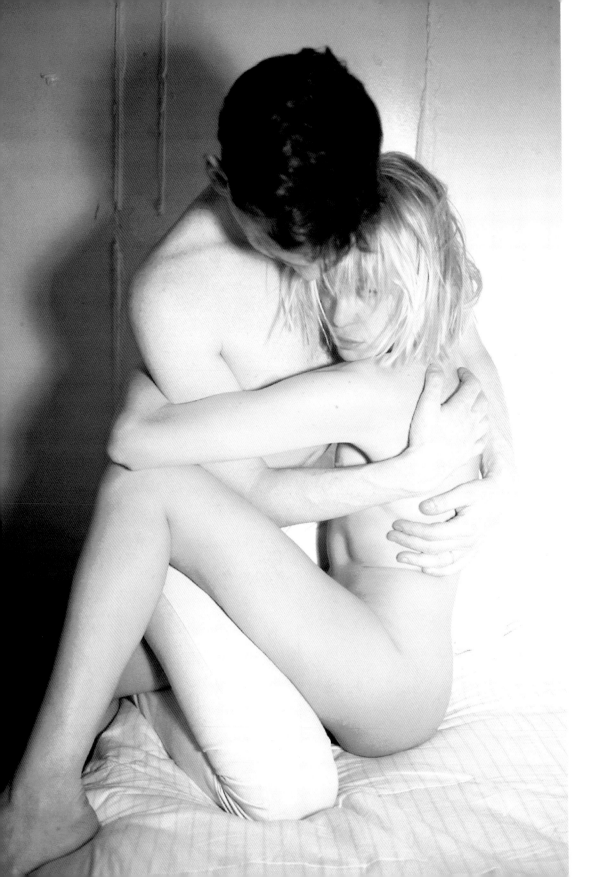

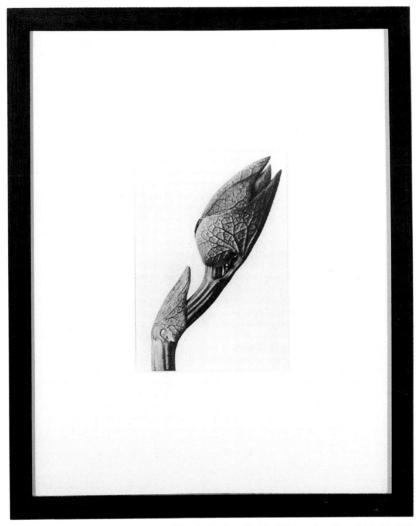

Sherrie Levine, Untitled (After Karl Blossfeldt: 2), 1990

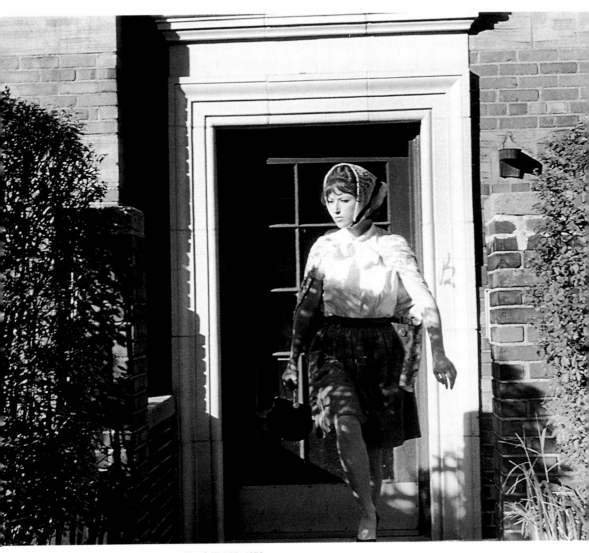

Cindy Sherman, Untitled Film Still # 20, 1978

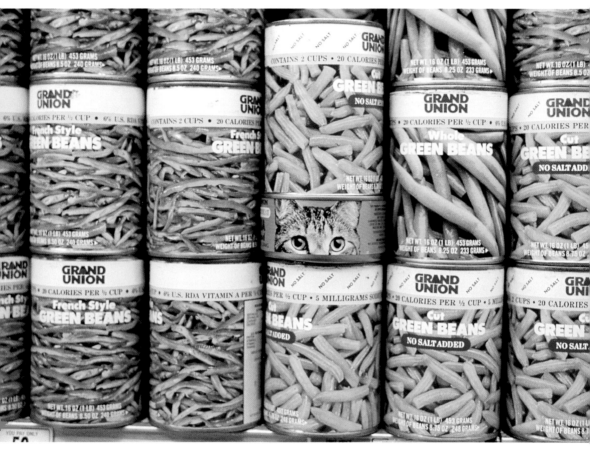

Gabriel Orozco, Cat in Jungle, 1992

Gabriel Orozco, Common Dream, 1996

Andy Grundberg

Art and Photography, Photography and Art: Across the Modernist Membrane

The year is 1962. Andy Warhol and Robert Rauschenberg, independently but almost simultaneously, begin using the silkscreen process to put photographs onto canvas. The Sidney Janis Gallery in New York exhibits Warhol, Roy Lichtenstein, and James Rosenquist in a show called "New Realists," giving birth to what quickly becomes known as Pop art. In Los Angeles, Ed Ruscha publishes *26 Gasoline Stations*, a commercially printed artist's book of deadpan photographs that announces the arrival of Conceptual art to those who are listening.

At the Museum of Modern Art in New York, home to one of the very few museum departments of photography, John Szarkowski is named Director of Photography, succeeding Edward Steichen.

Due to his erudition, eloquence, and literary grace, Szarkowski comes to define the aspirations for photography as an art for much of the next two decades. His point of view, espoused in *The Photographer's Eye* as well as in the exhibitions he organizes, is that photography achieves the status of art when it refers to its own capabilities and traditions. This essentially Modernist notion, taken to its extreme, means that photography should be about photography in the same way that critic

Clement Greenberg, in valorizing abstraction, asked painting to be about painting.

Unfortunately, at least for Szarkowski's brand of Modernist photography, the horses had already left the barn. Pop art, with its fascination for vernacular representations of popular, capitalist culture, and Conceptual art, with its interest in systems of information and signs, would conspire to create an atmosphere in which hybrid practices, not pure ones, prevailed. Photographs, those omnipresent, seemingly inescapable products of cultural information — as well as their allied forms of lens-based image making, film and video — would become part and parcel of contemporary art.

The year is now 1977. At Artists' Space, a nonprofit contemporary art center in New York, a group exhibition called "Pictures" appears. Organized by Douglas Crimp and featuring Troy Brauntuch, Jack Goldstein, Sherrie Levine, Robert Longo, and Philip Smith, "Pictures" is at once a revival of Pop attitudes toward visual culture and a theoretical watershed. In his catalogue essay, Crimp writes: "To an ever greater extent our experience is governed by pictures, pictures in newspapers and magazines, on television and in the cinema. Next to these pictures, first-hand experience begins to retreat, to seem more and more trivial. While it once seemed that pictures had the function of interpreting reality, it now seems that they have usurped it. It therefore becomes imperative to understand the picture itself, not in order to uncover a lost reality but to determine how a picture becomes a signifying structure of its own accord."[1]

Crimp's announcement of the lenticular condition of contemporary culture coincides with the advent of a whole new series of artistic interventions deploying the photograph as a means of critique. The same year that "Pictures" appears in New York, both Sherrie Levine and Richard Prince begin to "rephotograph" magazine images and other reproductions and to re-present them as their own. In Buffalo, New York, where Robert

Christian Boltanski, Composition photographique, 1977

Longo and Charles Clough are leading an art scene centered around a re-gional artists' space, Hallwalls, Cindy Sherman stages the first photographs in what is to become her landmark series of *Untitled Film Stills*.

Also in 1977, the Museum of Modern Art presents "Mirrors and Windows", John Szarkowski's attempt to summarize American photog-raphy since 1960 as a self-conscious art practice. The exhibition does remarkably little to explain the peculiar turns that the medium had taken since Szarkowski became the full-time guardian and explicator of its traditions, nor does it take cognizance of what Abigail Solomon-Godeau would later call "photography after art photography."[2] Postmodernism is being born, but neither the Museum of Modern Art nor any other of photography's existing institutional structures recognizes it.

The year is now 1997. Today the medium of photography can be seen from a vastly different perspective, one that recognizes the truth of Solomon-Godeau's assertion that "Virtually every critical and theoretical issue with which postmodernist art may be said to engage in one sense or another can be located within photography."[3] The range of artists who make or use photographs as part of their art is wide, both geographically and aesthetically: Christian Boltanski, Chuck Close, Jim Dine, Mike Kelley, Anselm Kiefer, Jack Pierson, Gerhard Richter, to cite but a few. The display and the critical apprehension of photographs so suffuses contemporary art that they often go unrecognized as photographs.

It is important to point out, however, that the difference between the position of photography within the visual arts in our postmodernist era and the position it assumed in earlier years is not the widespread adoption of the camera by artists but the specific roles that photographs play in current artistic practices. Art historians have uncovered a largely covert history of photographic practice by painters and sculptors that goes back almost to the moment of photography's public announcement in 1839. Edgar Degas is one obvious example of a painter who looked to photographs as a means of depicting the flow of contemporary life. The Italian Futurists were

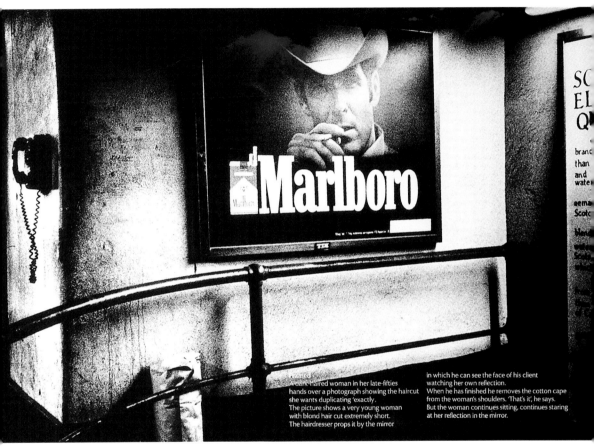

Framed
A dark-haired woman in her late-fifties
hands over a photograph showing the haircut
she wants duplicating 'exactly.'
The picture shows a very young woman
with blond hair cut extremely short.
The hairdresser props it by the mirror
in which he can see the face of his client
watching her own reflection.
When he has finished he removes the cotton cape
from the woman's shoulders. 'That's it', he says.
But the woman continues sitting, continues staring
at her reflection in the mirror.

Victor Burgin, Framed US/77, 1977

In addition, photography was tainted because it was not
fundamentally a product of the hand. This is why today we
still speak discretely of artists and photographers, of art
and photography, of art history and photography history.

able to depict motion on canvas by using the visual rhetoric of the photo-
graphs of Jules-Etienne Marey. In the early years of the twentieth century,
Constantin Brancusi took photographs as an adjunct to his sculptural
practice, and Charles Sheeler used the camera much as he used the brush,
and as frequently.

Such an interchange between photography and the more tradi-
tional (and more marketable) media of painting, drawing, and sculpture
was often covert in part because the tenets of Modernism placed a high
value on the purity of media, which were assumed to be both individual
and independent. In addition, photography was tainted because it was not
fundamentally a product of the hand. This is why today we still speak dis-
cretely of artists and photographers, of art and photography, of art history
and photography history. Until the most recent revision of H.W. Janson's
History of Art, for example, photography was not even considered a sub-
ject. Conversely, Beaumont Newhall's venerable *History of Photography*
virtually ignores painting; the positioning of photography as an art is
presented as a consequence of advancing photographic technology, not
as relational to artistic styles and aesthetics present in painting and
sculpture.

Revisionist historians of art are now engaged in revisiting and
rectifying the often arbitrary separation of the traditions of photography
and the other visual arts, starting with its inventors: Daguerre, a professio-
nal painter engaged in spectacles, and Talbot, a frustrated amateur unable
to master drawing from the camera obscura. What they cannot revise is

Richard Prince, Untitled, 1981

Richard Prince, Untitled (Girlfriend), 1993

the historical imposition, primarily during this century, of separate structures, institutions, and audiences for photography. Because of these Modernist inventions, photography today retains a vestigial sense of its artistic independence and a set of artisanal artistic practices unique unto itself. The inherent instability of the separate-but-equal situation has made itself manifest at museums like the Museum of Modern Art in New York, whose Department of Photography, in the post-Szarkowski 1990s, has struggled to extend its canon to accommodate Cindy Sherman as well as Edward Weston. This superficial effort is not without irony: while the photography department recently purchased a complete set of Sherman's *Untitled Film Stills* made in the late 1970s, the museum's first Sherman image was acquired some ten years earlier by the Department of Painting and Sculpture.

Yet the photograph's most interesting presence within the visual arts in the second half of this century, I would argue, comes not from this apartheid lineage but from hybrid practices that recognize the camera as the source and creator of the world of images in which we live—that is to say, as a font of representation. This notion suffuses the work of those who are identified as artists—Vik Muniz, for example, or Barbara Kruger—and those who are identified as photographers—David Levinthal, Zoe Leonard, Rineke Dijkstra. Whether we trace these practices back to Pop art or to the evolution of Conceptual art in the 1970s—or back even further to Constructivism, Dada, and Surrealism—they themselves represent the ultimate (and ultimately ironic) success of Alfred Stieglitz's lifelong quest to have photography attain full status as a form of art.

That this recognition should span Gerhard Richters's *Atlas* as well as Nan Goldin's *Ballad of Sexual Dependency* is a testament to the permeability that exists between the current status realms of photographers-making-art and artists-making photographs. What Richter and Goldin have in common (besides a widespread popularity in the art world) is an implicit belief in the photograph's ongoing ability to convey the kind of authentic,

firsthand information that Crimp declared obsolete. This suggests photography's current dilemma much more than the artist/photographer divide: while functioning to remind us of representation as a fact of life, photographs seemingly are also quite capable of personifying individual attitudes about that life. Pointed like a declinating compass not only to the postmodern condition of *déjà vu* but also to a tangential heading that seems to offer a possibility of escape, photography is ever more central to the possibilities of contemporary art.

If the issue for photography at the beginning of the century was whether the medium could be art, the issue it faces at the end of the twentieth century is whether photography can ever again be wholly itself. That is to say, does it mean anything to speak of there being a medium of photography at a time when hybridity seems *de rigueur,* or are we left simply with photographs, those tantalizing everyday images that signify veracity, history, memory, presence, absence? In our increasingly digital age, the tendency is to consider photographs as cultural relics and, as with all good relics, to relegate them to the museum and the archive. But before they go gently into that good night, they continue to function as both objects and subjects of the visual world. They do so based not on the characteristics that appealed to Modernists — descriptiveness, objectivity, clarity, fixity, singularity — but on their Postmodernist counterparts — allusiveness, stereotypicality, abundance, excess, mystery. It is in this sense that photography has been fundamentally and irrevocably redefined over the past twenty years.

[1] Douglas Crimp, *Pictures*, exhibition catalogue, New York 1977, p. 3. Quoted in Whitney Museum of American Art (ed.), *Image World*, New York 1989, p. 67.

[2] Abigail Solomon-Godeau, "Photography After Art Photography," in Brian Wallis (ed.), *Art After Modernism: Rethinking Representation*, New York 1984, pp. 75–85.

[3] *Ibid.*, p. 80.

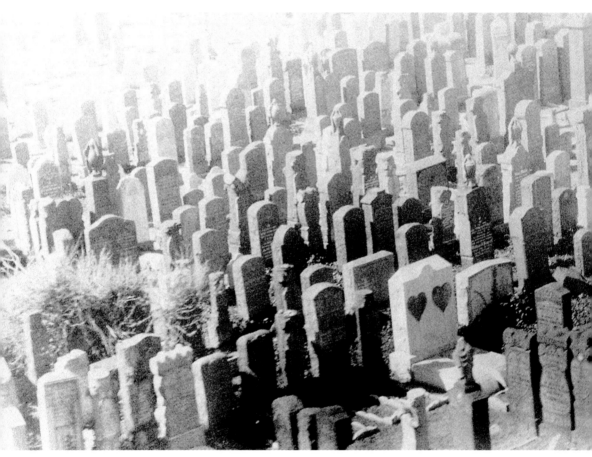

Zoe Leonard, Gravestone (2 Hearts), 1985 – 91

Wolfgang Tillmans, Alex & Lutz holding each other, 199

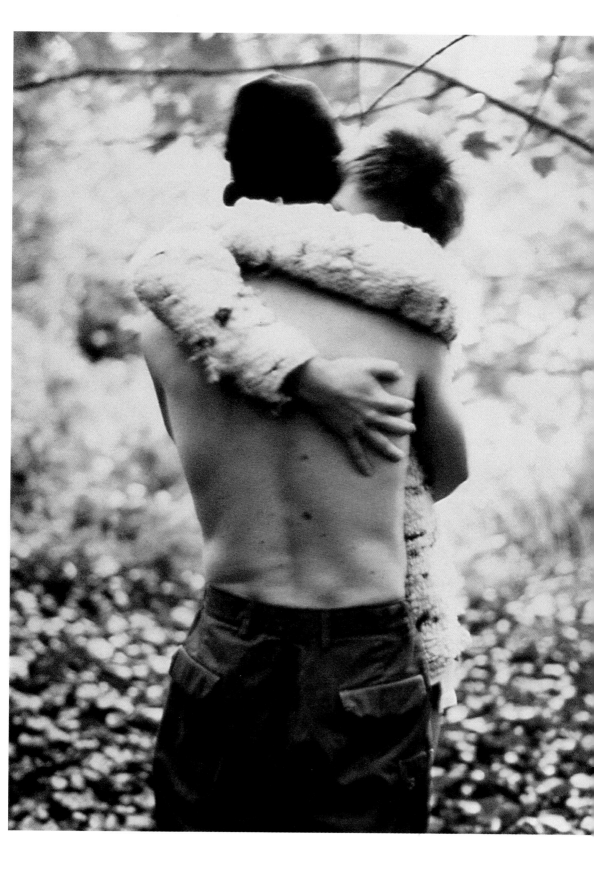

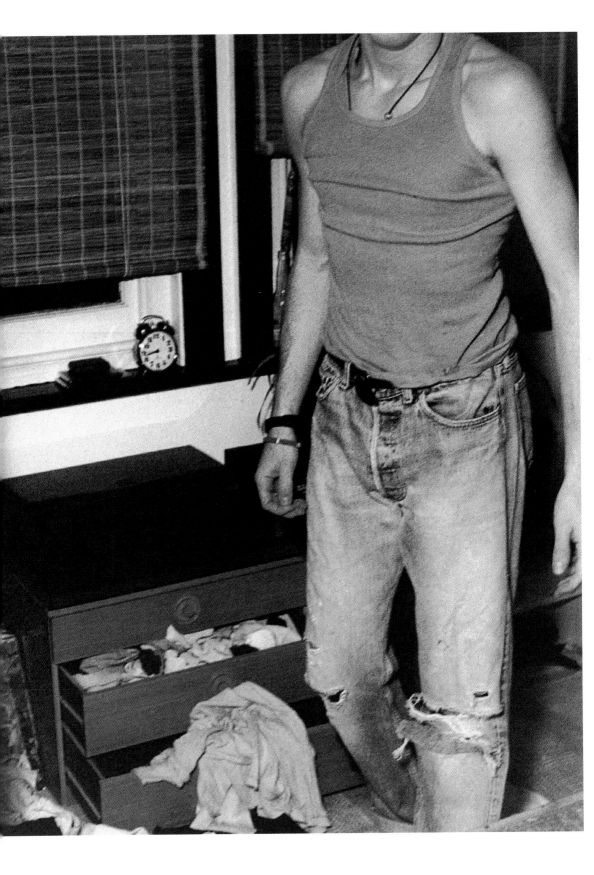

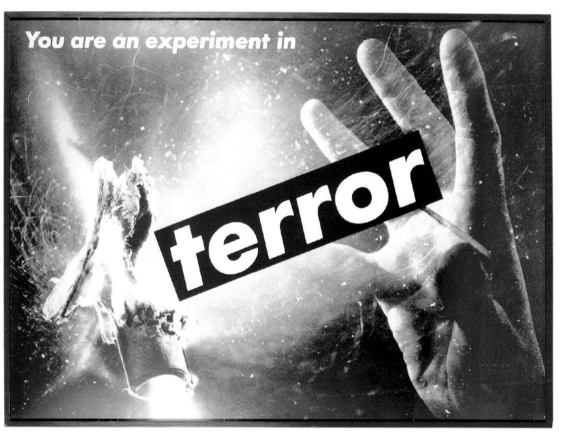

Barbara Kruger, Untitled, 1983

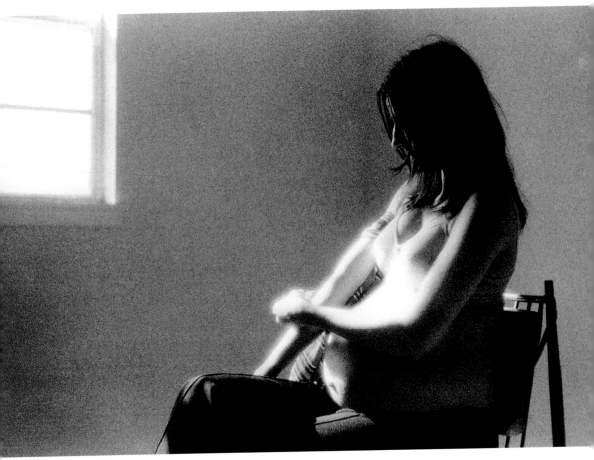

Larry Clark, Tulsa 1968 – 71, 1972

Zoe Leonard, Untitled, 1990/9

Nan Goldin, Cookie with me after I was punched, Baltimore, Md., 1986

Laura Cottingham

Re-framing the Subject: Feminism and Photography

The insights of second-wave feminism have significantly con-
tributed to an adjustment of the way we find meaning in and through photog-
raphy. In addition to the general challenges to modernist art practice, Seven-
ties feminism — claiming the personal as political, rewriting the art-historical
canon against the patrilinear unwriting of female contributions, introducing
autobiography, reclaiming craft and domestic labor, and centralizing female
subjectivity against the universalization of male experience — has assisted in
restructuring our sense of photographic representation and production in
particular and discernible ways.

Most apparently, the spectacularization of the female body as a
natural, inevitable, and appropriate register of the camera's gaze — a system
of representation borrowed by Edward Weston, Alfred Stieglitz, Man Ray and
so many others from the 19th-century iconography of European painting — has
become problematized according to the politics of representation that was
introduced and developed through feminist discourse. The central aesthetic
question posed by the diverse activities associated with Seventies feminism
was originally delivered within the simplistic form that molds all radical ob-
servations when they first take shape enough to be recognized on the cultural
landscape. Second-wave feminism, distinguished by its appearance within
visual art as well as in political space, asked quite simply: Why is woman so

often the object and so seldom or never the subject or author of art? Theoretical developments from this basic formulation continue to unfold and implode, and will no doubt continue as long as women have reason to challenge the terms of our situations. In regards to the specific ontology, practice, and distribution of photography, feminist theory had no choice but to implicate traditional photographic assumptions, including those of fine art as well as commercial practices. Imbued with an aim toward a "captured reality" and a direct mirror on the observable, traditional photographic practice was called into question by theorists as readily as were the sexist contours of mainstream representations of women in advertising and commercial cinema. In Great Britain especially, photographic assumptions and the very process of "looking" emerged as an important site of contest for feminist scrutiny: Laura Mulvey demonstrated the cinematic hegemony of the "male gaze"; John Berger critiqued modes of female representation in art and advertising according to their collusion with male ownership of the female; and Griselda Pollock argued for the necessity of distinguishing between "women" and "images of women".

The philosophical and political implications that emanate from these and other second-wave formulations continue to irritate and confound the dominant visual arts apparatus decades later. This narrative will no doubt continue into the next millennium as the dialectic between male and female, men and women, and the so-called masculine and feminine continues to play itself out. For visual artists, the question of how the self is constructed in society, especially through the dominant modes of representation orchestrated by advertising and television and whatever passes for history at any given moment, will necessarily remain a concern that is as informed by feminist insights as by any other body of cultural thought.

In actual Seventies feminist art practice, photography perhaps played a relatively small role to the extent that the medium was secondary to two of the most favored practices of the period: performance and video.

In Seventies performance practices, photography was not the primary medium, but it was a necessary secondary medium: a messenger who delivered performance pieces into art space, art discourse, and art history.

Although the relationship between photography and video is somewhat obvious (and perhaps it is fair to assume that if video had not become technically available in Europe and the United States during the late 1960s, then more artists would have worked with still photography — and in different ways — during the 1970s), the coextensive partnership between photography and performance developed in accordance with a desire to make at least partially permanent works that were fugitive by definition. In addition, photographic documentation allowed performance pieces partial entry into the standard distribution system established for the fine arts. Photography offered the proof and the promise that such actions as Valie Export entering a movie theater with her pubic hair exposed through a deliberate cut in the crotch of her blue jeans (Valie Export, *Genital Panic*, 1969), or Gina Pane slicing her feet on a razor-studded ladder in Innsbruck or piercing her arm with thumbtacks in a gallery in Paris (various actions by Gina Pane, 1960s and 1970s), or Carolee Schneemann reading from a text she pulled out of her vagina in front of a film audience in Colorado (Carolee Schneemann, *Interior Scroll*, 1972), or Adrian Piper walking down the sidewalks of New York City dressed as an African American man reciting a nonsensical mantra (Adrian Piper, *The Mythic Being*, various performances, 1970s) did in fact happen. Although some of these and other performance works from the 1970s were also recorded by film or video, still photography was the most prevalent form of performance documentation during the period, given its relative accessibility — in expense as well as technical ease — when compared to film or the early Portapack half-inch, reel-to-reel video cameras. In Seventies performance practices, photography was not

I was eighteen years old. I rang the bell. He opened the door. He was wearing the same bathrobe as my father. A long white terrycloth robe. He became my first love. For an entire year, he obeyed my request and never let me see him naked from the front. Only from the back. And so, in the morning light, he would get up carefully turning himself away, and gently hiding inside the white bathrobe. When it was all over he left the bathrobe behind with me.

the primary medium, but it was a necessary secondary medium: a messenger who delivered performance pieces into art space, art discourse, and art history.

At the basis of both the conceptual and feminist art movements was an understanding that reality, as currently constructed, is not enough—in fact, it has to change. In contrast to the late 19th- and early 20th-century photographers who sought out clever *carrefours* in Paris, ancient monuments in Cairo, the heads of distinguished urban personages, the formal simplicity of the then-undisturbed American West, or a perfectly formed pepper, when performance artists used photography as documentation during the 1960s and 1970s, they compelled the camera to record a reality that they themselves had deliberately manufactured.

In post-Seventies art practices, the legacy of performative gestures is sometimes found to endure in an incipient or partial guise. Much of Sophie Calle's work, including in pieces such as *Autobiographical Stories (The Bathrobe)*, 1988–89, inscribe the narratives of memory and experience in subtle installations of photographs and text that function like the program notes that are all that remain after a performance is over. Even more obvious is the œuvre of Cindy Sherman, whose fictive "self-portraits" produce a narrative in which the process of seeing through received images—both cinematic and art historical—is rendered apparent. A synthesis of the performative and the readymade, Sherman's documents reiterate the traditional symbolic function of the female image as metaphor and spectacle while simultaneously engaging in the authorial shift of tremendous consequence anticipated and called for in Seventies feminism. In some works from the 1990s, such as Janine Antoni's *Momme*, 1995–96, which features the artist hidden under her mother's dress, the performative aspect of the work is incorporated into the staging of the photograph itself; in this sense, contrary to Seventies practices, the process of taking the photograph is itself a form or performance. Or, in the series of images Zoe Leonard produced to accompany Cheryl Dunye's film, *The Watermelon*

Janine Antoni, Momme, 1995/96

Woman, 1996, photographs are forged to appear as snapshots and publicity stills of the African American lesbian actress whose history is the focus of Dunye's pseudo-documentary. The actress never existed: Dunye and Leonard's projects call into question the impossibility and speciousness of locating a history, such as that of lesbians and African Americans, that has been deliberately obfuscated by the white male parent culture. Leonard and Dunye's presentation of a deliberately faked "history" is a Nineties twist on the call for revisionist art history ushered in by feminists during the early 1970s.

The pointed scrutiny of social, political and daily life as introduced through feminist consciousness encouraged visual practices that played with received representations taken from cinema, advertising and other sites of popular and mass culture. Early pieces by Annette Messager featured mass-produced images of women altered and transformed by the artist's line drawings; while Nicole Gravier, who was also working in France during the late 1970s, produced a series of re-photographs that feature her own bodily interaction with color images taken from magazine advertisements. Feminist-inspired interventions with mass market commercial imagery ran parallel to the interplay with social life actualized in so many of the performance works, as they were similarly motivated by a desire to situate the female body — and the self — in representational space in order to alter and transform the pictorial as well as the political position of women.

The constituent importance of mass-media imagery in the construction, organization, and maintenance of personal life and political structures is accepted by artists like Barbara Kruger as *de facto;* she utilizes photographs as material, rather than relying on photography as medium. For Kruger, the received world of popular culture produces the reservoir of pictures and ideology from which she chooses representations to isolate, re-situate, and mitigate with textual juxtapositions. Although photography is at the center of Kruger's practice, it is important to con-

sider that she has never produced a photograph: her photographic images are borrowed, then technically and conceptually altered.

Contemporary photography in the 1990s is more self-conscious than it was or could have been in the first hundred years of the medium's technical and artistic development. Photography's original position as the bastard child of the visual arts no longer applies, as more recent media — including video as well as inter-media and web sites — now carry the stigma of illegitimacy previously assigned to still photography and cinema. Although the most irrevocably significant contribution of second-wave feminism has been to shift female subjectivity into the center of the frame and to demand a place for female authorial presence, the theoretical contributions of feminist theory and art practice have also opened up new possibilities for how photography is used and understood as a medium, a material, and a message.

Cindy Sherman, Untitled Film Still # 55, 1980

Cindy Sherman, Untitled # 92, 1981

Mona Hatoum, Van Gogh's Back, 1995

Jeff Wall

Marks of Indifference: Aspects of Photography in, or as, Conceptual Art[1]

Conceptual art played an important role in the transformation of the terms and conditions within which art-photography defined itself and its relationships with the other arts, a transformation resulting from the experiments of the 1960s and 1970s, which established photography as an institutionalized modernist form evolving explicitly through the dynamics of its auto-critique.

Photography's implication with modernist painting and sculpture was not, of course, developed in the 1960s; it was central to the work and discourse of the art of the 1920s. But, for the Sixties generation, art-photography remained too comfortably rooted in the pictorial traditions of modern art; it had an irritatingly serene, marginal existence, a way of holding itself at a distance from the intellectual drama of avant-gardism while claiming a prominent, even definitive place within it. The younger artists wanted to disturb that, to uproot and radicalize the medium, and they did so with the most sophisticated means they had in hand at the time, the auto-critique of art identified with the tradition of the avant-garde. Their approach implied that photography had not yet become "avant-garde" in 1960 or 1965, despite the epithets being casually applied to it. It had not yet accomplished the preliminary auto-dethronement, or deconstruction, which the other arts had established as fundamental to their development and their *amour-propre.*

Through that auto-critique, painting and sculpture had moved away from the practice of depiction, which had historically been the foundation of their social and aesthetic value. Although we may no longer accept the claim that abstract art had gone "beyond" representation or depiction, it is certain that such developments added something new to the corpus of possible artistic forms in Western culture. In the first half of the 1960s, Minimalism was decisive in bringing back into sharp focus, for the first time since the 1930s, the general problem of how a work of art could validate itself as an object among all other objects in the world. Under the regime of depiction, that is, in the history of Western art before 1910, a work of art was an object whose validity as art was constituted by its being, or bearing, a depiction. In the process of developing alternative proposals for art "beyond" depiction, art had to reply to the suspicion that, without their depictive, or representational function, art objects were art in name only, not in body, form, or function.[2] Art projected itself forward bearing only its glamorous traditional name, thereby entering a troubled phase of restless searching for an alternative ground of validity. This phase continues, and must continue.

Photography cannot find alternatives to depiction, as could the other fine arts. It is in the physical nature of the medium to depict things. In order to participate in the kind of reflexivity made mandatory for modernist art, photography can put into play its own necessary condition of being a depiction-which-constitutes-an-object. In its attempts to make visible this condition, Conceptual art hoped to reconnect the medium to the world in a new, fresh way, beyond the worn-out criteria for photography as sheer picture-making.

From Reportage to Photodocumentation

Photography entered its post-Pictorialist phase (one might say its "post-Stieglitzian" phase) in an exploration of the border-territories of

the utilitarian picture. In this phase, which began around 1920, important work was made by those who rejected the Pictorialist enterprise and turned toward immediacy, instantaneity, and the evanescent moment of the emergence of pictorial value out of a practice of reportage of one kind or another. A new version of what could be called the "Western Picture," or the "Western Concept of the Picture," appears in this process.

The Western Picture is, of course, the *tableau*, that independently beautiful depiction and composition that derives from the institutionalization of perspective and dramatic figuration at the origins of modern Western art, with Raphael, Dürer, Bellini and the other familiar *maestri*. It is known as a product of divine gift, high skill, deep emotion, and crafty planning.

Pictorialist photography was dazzled by the spectacle of Western painting and attempted, to some extent, to imitate it in acts of pure composition. Lacking the means to make the surface of its pictures unpredictable and important, the first phase of Pictorialism, Stieglitz's phase, emulated the fine graphic arts, re-invented the beautiful look, set standards for gorgeousness of composition, and faded. Without a dialectical conception of its own surface, it could not achieve the kind of planned spontaneity painting had put before the eyes of the world as a universal norm of art. By 1920, photographers interested in art had begun to look away from painting, even from modern painting, toward the vernacular of their own medium, and toward the cinema, to discover their own principle of spontaneity, to discover once again, for themselves, that unanticipated appearance of the Picture demanded by modern aesthetics.

At this moment the art-concept of photojournalism appears, the notion that art can be created by imitating photojournalism. This imitation was made necessary by the dialectics of avant-garde experimentation. Non-autonomous art-forms, like architecture, and new phenomena such

as mass communications, became paradigmatic in the 1920s and 1930s because the avant-gardes were so involved in a critique of the autonomous work of art, so intrigued by the possibility of going beyond it into a utopian revision of society and consciousness. Photojournalism was created in the framework of the new publishing and communications industries, and it elaborated a new kind of picture, utilitarian in its determination by editorial assignment and novel in its seizure of the instantaneous, of the "news event" as it happened. For both these reasons, it seems to have occurred to a number of photographers that a new art could be made by means of a mimesis of these aims and aspects of photography as it really existed in the world of the new culture industries.

This mimesis led to transformations in the concept of the Picture that had consequences for the whole notion of modern art, and that therefore stand as preconditions for the kind of critique proposed by the Conceptual artists after 1965. Post-pictorialist photography is elaborated in the working out of a demand that the Picture make an appearance in a practice which, having already largely relinquished the sensousness of the surface, must also relinquish any explicit preparatory process of composition. Acts of composition are the property of the tableau. In reportage, the sovereign place of composition is retained only as a sort of dynamic of anticipatory framing, a "hunter's consciousness," the nervous looking of a "one-eyed cat," as Lee Friedlander put it. Every picture-constructing advantage accumulated over centuries is given up to the jittery flow of events as they unfold. The rectangle of the viewfinder and the speed of the shutter, photography's "window of equipment," is all that remains of the great craft-complex of composition. The art-concept of photojournalism began to force photography into what appears to be a modernist dialectic. By divesting itself of the encumbrances and advantages inherited from older art forms, reportage, or the spontaneous, fleeting aspect of the photographic image, pushes toward a discovery of qualities apparently intrinsic to the medium, qualities that must necessarily distinguish the medium from

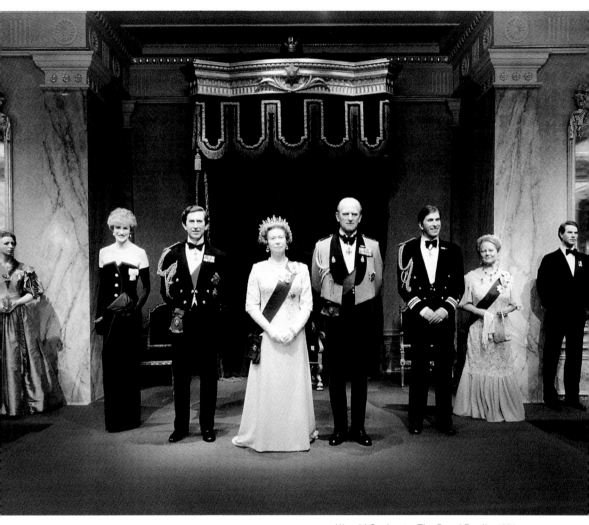

Hiroshi Sugimoto, The Royal Family, 1994

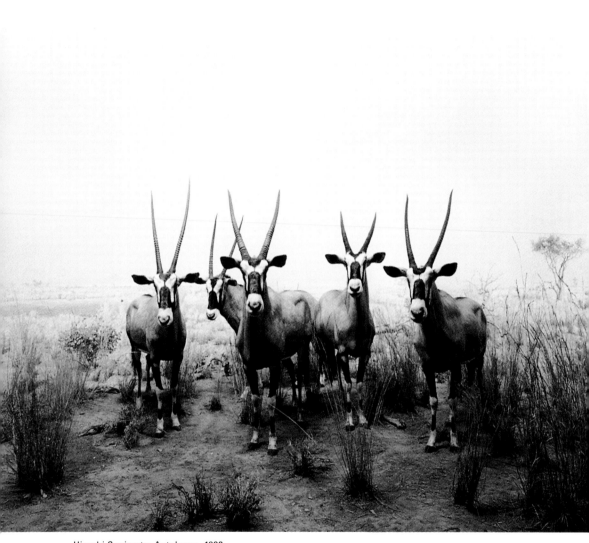

Hiroshi Sugimoto, Antelopes, 1982

others, and through the self-examination of which it can emerge as a modernist art on a plane with others.

In this process, photography elaborates its version of the Picture, and it is the first new version since the onset of modern painting in the 1860s, if one considers abstract paintings to be, in fact, pictures anymore. A new version of the Picture implies necessarily a turning-point in the development of modernist art. Problems are raised which will constitute the intellectual content of Conceptual art, or a least significant aspects of that content.

One of the most important critiques opened up in Conceptual art was that of art-photography's achieved or perceived "aestheticism." The revival of interest in the radical theories and methods of the politicized and objectivistic avant-garde of the 1920s and 1930s has long been recognized as one of the most significant contributions of the art of the 1960s, particularly in America. Productivism, "factography," and Bauhaus concepts were turned against the apparently "depoliticized" and resubjectivized art of the 1940s and 1950s. Thus, we have seen that the kind of formalistic and "re-subjectivized" art photography that developed around Edward Weston and Ansel Adams on the West Coast, or Harry Callahan and Aaron Siskind in Chicago in those years (to use only American examples) attempted to leave behind *not only* any *link* with agit-prop, but even any connection with the nervous surfaces of social life, and to resume a stately modernist pictorialism. This work has been greeted with opprobrium from radical critics since the beginnings of the new debates in the 1960s. The orthodox view is that Cold War pressures compelled socially-conscious photographers away from the borderline forms of art-photojournalism toward the more subjectivistic versions of *art informel.* In this process, the more explosive and problematic forms and concepts of radical avant-gardism were driven from view, until they made a return in the activistic neo-avant-gardism of the 1960s. There is much truth in this construction but it is flawed in that it draws too sharp a line between the methods and

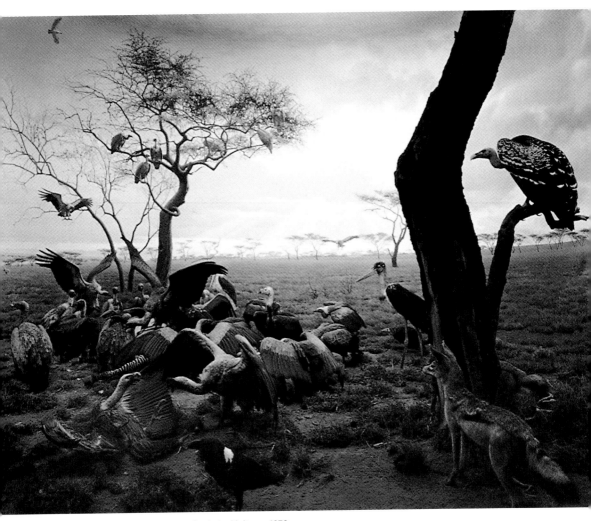

Hiroshi Sugimoto, Hyena – Jackal – Vulture, 1976

approaches of politicized avant-gardism and those of the more subjecti-
vistic and formalistic trends in art-photography.

The entire avant-garde of the 1920s and 1930s was aware that
validity as reportage *per se* was insufficient for the most radical of pur-
poses. What was necessary was that the picture not only succeed as
reportage and be socially effective, but that it succeed in putting forward
a new proposition or model of the Picture. Only in doing both these things
simultaneously could photography realize itself as a modernist art form,
and participate in the radical and revolutionary cultural projects of that era.
In this context, rejection of a classicizing aesthetic of the picture — in the
name of proletarian amateurism, for example — must be seen as a claim
to a new level of pictorial consciousness.

Thus, art-photography was compelled to be both anti-aestheti-
cist and aesthetically significant, albeit in a new "negative" sense, at the
same moment. Here, it is important to recognize that it was the content
of the avant-garde dialogue itself that was central in creating the demand
for an aestheticism which was the object of critique by that same avant-
garde.

The peculiar, yet familiar, political ambiguity *as art* of the ex-
perimental forms in and around Conceptualism, particularly in the context
of 1968, is the result of the fusion, or even confusion, of tropes of art-
photography with aspects of its critique. Far from being anomalous, this
fusion reflects precisely the inner structure of photography as potentially
avant-garde or even neo-avant-garde art. This implies that the new forms
of photographic practice and experiment in the 1960s and 1970s did not
derive exclusively from a revival of anti-subjectivist and anti-formalist ten-
dencies. Rather, the work of figures like Douglas Huebler, Robert Smithson,
Bruce Nauman, Richard Long, or Joseph Kosuth emerge from a space con-
stituted by the already-matured transformations of both types of approach
— factographic and subjectivist, activist and formalist, "Marxian" and
"Kantian"— present in the work of their precursors in the 1940s and 1950s,

in the intricacies of the dialectic of "reportage as art-photography," as art-photography *par excellence.* The radical critiques of art-photography inaugurated and occasionally realized in Conceptual art can be seen as both an overturning of academicized approaches to these issues, and as an extrapolation of existing tensions inside that academicism, a new critical phase of academicism and not simply a renunciation of it. Photo-conceptualism was able to bring new energies from the other fine arts into the problematic of art-photojournalism, and this tended to obscure the ways in which it was rooted in the unresolved but well-established aesthetic issues of the photography of the 1940s and 1950s.

Amateurization

Photography, like all the arts that preceded it, is founded on the skill, craft, and imagination of its practitioners. It was, however, the fate of all the arts to become modernist through a critique of their own legitimacy, in which the techniques and abilities most intimately identified with them were placed in question. The wave of reductivism that broke in the 1960s had, of course, been gathering during the preceding half-century, and it was the maturing (one could almost say, the totalizing) of that idea that brought into focus the explicit possibility of a "conceptual art," an art whose content was none other than its own idea of itself, and the history of such an idea's becoming respectable.

Painters and sculptors worked their way into this problem by scrutinizing and repudiating — if only experimentally — their own abilities, the special capacities that had historically distinguished them from other people — non-artists, unskilled or untalented people. This act of renunciation had moral and utopian implications. For the painter, a radical repudiation of complicity with Western traditions was a powerful new mark of distinction in a new era of what Nietzsche called "a revaluation of all values."[3] Moreover, the significance of the repudiation was almost imme-

diately apparent to people with even a passing awareness of art, though apparent in a negative way. "What! You don't want things to look three-dimensional? Ridiculous!" It is easy to experience the fact that something usually considered essential to art has been removed from it. Whatever the thing the artist has thereby created might appear to be, it is first and foremost that which results from the absence of elements which have hitherto always been there. The reception, if not the production, of modernist art has been consistently formed by this phenomenon, and the idea of modernism as such is inseparable from it. The historical process of critical reflexivity derives its structure and identity from the movements possible in, and characteristic of, the older fine arts, like painting. The drama of modernization, in which artists cast off the antiquated characteristics of their *métiers*, is a compelling one, and has become the conceptual model for modernism as a whole.

It is a commonplace to note that it was the appearance of photography which, as the representative of the Industrial Revolution in the realm of the image, set the historical process of modernism in motion. Yet photography's own historical evolution into modernist discourse has been determined by the fact that, unlike the older arts, it cannot dispense with depiction and so, apparently, cannot participate in the adventure it might be said to have suggested in the first place.

The dilemma, then, in the process of legitimating photography as a modernist art is that the medium has virtually no dispensable characteristics, the way painting, for example, does, and therefore cannot conform to the ethos of reductivism, so succinctly formulated by Clement Greenberg in "Modernist Painting."

Photography constitutes a depiction not by the accumulation of individual marks, but by the instantaneous operation of an integrated mechanism. All the rays permitted to pass through the lens form an image immediately, and the lens, by definition, creates a focused image at its

It is a commonplace to note that it was the appearance
of photography which, as the representative of the Industrial
Revolution in the realm of the image, set the historical
process of modernism in motion.

correct focal length. Depiction is the only possible result of the camera
system, and the kind of image formed by a lens is the only image possible
in photography. Thus, no matter how impressed photographers may have
been by the analytical rigor of modernist critical discourse, they could not
participate in it directly in their practice because the specificities of their
medium did not permit it. This physical barrier has a lot to do with the
distanced relationship between painting and photography in the era of
art-photography, the first sixty or so years of this century.

Despite the barrier, around the middle of the 1960s, numerous
young artists and art students appropriated photography, turned their
attention away from *auteurist* versions of its practice, and forcibly sub-
jected the medium to a full-scale immersion in the logic of reductivism.
The essential reduction came on the level of skill. Photography could
be integrated into the new radical logics by eliminating all the pictorial
suavity and technical sophistication it had accumulated in the process of
its own imitation of the Great Picture. It was possible, therefore, to test
the medium for its indispensable elements, without abandoning depiction,
by finding ways to legitimate pictures that demonstrated the absence of
the conventional marks of pictorial distinction developed by the great
auteurs, from Atget to Arbus.

Already by around 1955, the revalorization and reassessment
of vernacular idioms of popular culture had emerged as part of a "new
objectivity," an objectivism bred by the limitations of lyrical *art informel,*
the introverted and self-righteously lofty art forms of the 1940s and 1950s.

It continues a fundamental project of the earlier avant-garde — the transgression of the boundaries between "high" and "low" art, between artists and the rest of the people, bringing mass-culture elements into high-culture forms, already by the 1920s the situation had become far more complex and reciprocal than that, and motifs and styles from avant-garde and high-culture sources were circulating extensively in the various new Culture Industries in Europe, the United States, the Soviet Union, and elsewhere. This transit between "high" and "low" had become the central problematic for the avant-garde because it reflected so decisively the process of modernization of all cultures. The great question was whether or not art as it had emerged from the past would be "modernized" by being dissolved into the new mass-cultural structures.

Hovering behind all tendencies toward reductivism was the shadow of this great "reduction." The experimentation with the "anaesthetic," with "the look of non-art," or with "the loss of the visual," is in this light a kind of tempting of fate. Behind the Greenbergian formulae, first elaborated in the late 1930s, lies the fear that there may be, finally, no indispensable characteristics that distinguish the arts, and that art as it has come down to us is very dispensable indeed. Gaming with the anaesthetic was both an intellectual necessity in the context of modernism, and at the same time the release of social and psychic energies which had a stake in the "liquidation" of bourgeois "high art." By 1960 there was pleasure to be had in this experimentation, a pleasure, moreover, which had been fully sanctioned by the aggressivity of the first avant-garde or, at least, important parts of it.

Radical deconstructions therefore took the form of searches for models of "the anaesthetic." Duchamp had charted this territory before 1920, and his influence was the decisive one for the new critical objectivisms surfacing forty years later with Gerhard Richter, Andy Warhol, Piero Manzoni, John Cage, and the rest. The anaesthetic found its emblem in the Readymade, the commodity in all its guises, forms, and traces. Working-

class, lower-middle class, suburbanite, and underclass milieux were expertly scoured for the relevant utilitarian images, depictions, figurations, and objects that violated all the criteria of canonical modernist taste, style, and technique. Sometimes the early years of Pop art seem like a race to find the most perfect, metaphysically banal image, that cipher that demonstrates the ability of culture to continue when every aspect of what had been known in modern art as seriousness, expertise, and reflexiveness had been dropped. The empty, the counterfeit, the functional, and the brutal themselves were of course nothing new as art in 1960, having all become tropes of the avant-garde via surrealism. From the viewpoint created by Pop art, though, earlier treatments of this problem seem emphatic in their adherence to the Romantic idea of the transformative power of authentic art. The anaesthetic is transformed as art, but along the fracture-line of shock. The shock caused by the appearance of the anaesthetic in a serious work is calmed by the aura of seriousness itself. It is this aura which becomes the target of the new wave of critical play. Avant-garde art had held the anaesthetic in place by a web of sophisticated manoeuvres, calculated transgressive gestures, which always paused on the threshold of real abandonment. Remember Bellmer's pornography, Heartfield's propaganda, Majakovsky's advertising. Except for the Readymade, there was no complete mimesis or appropriation of the anaesthetic, and it may be that the Readymade, that thing that had indeed crossed the line, provided a sort of fulcrum upon which, between 1920 and 1960, everything else could remain balanced.

Amateurism is a radical reductivist methodology insofar as it is the form of an impersonation. In photoconceptualism, photography posits its escape from the criteria of art-photography through the artist's performance as a non-artist who despite being a non-artist, is nevertheless compelled to make photographs. These photographs lose their status as representations before the eyes of their audience: they are "dull," "boring," and "insignificant." Only by being so could they accomplish the

Gordon Matta-Clark, Splitting (Englewood), 197

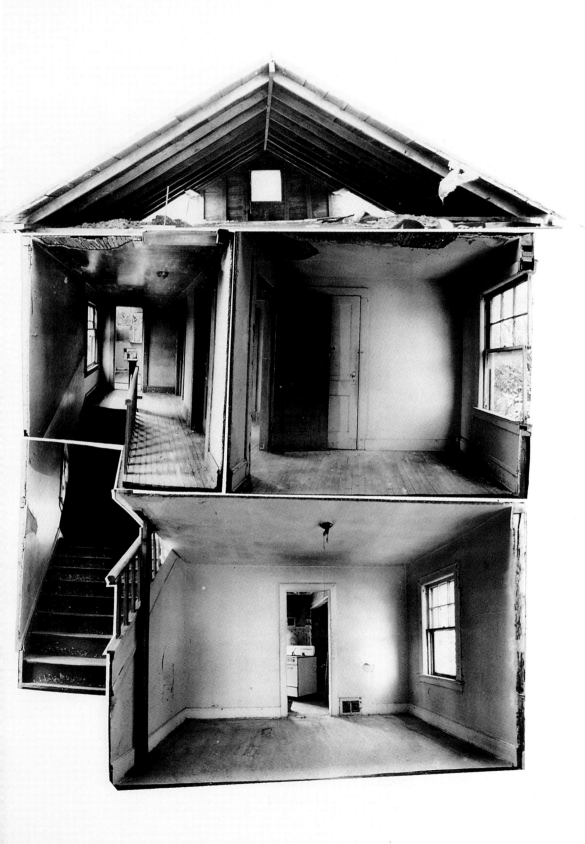

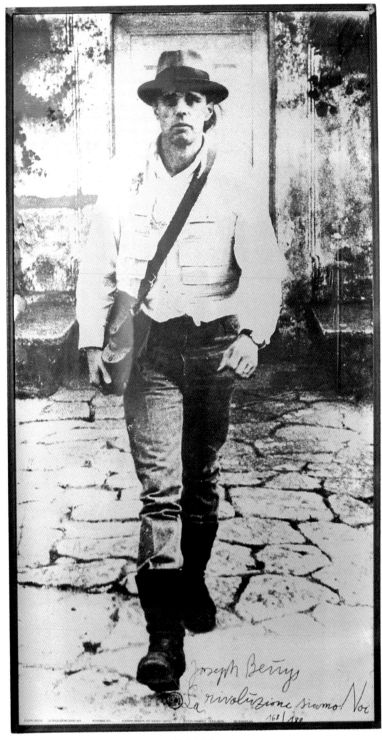

Joseph Beuys, La rivoluzione siamo Noi, 1972

intellectual mandate of reductivsm at the heart of the enterprise of Conceptual art. The reduction of art to the condition of an intellectual concept of itself was an aim which cast doubt upon any given notion of the sensuous experience of art. Yet the loss of the sensuous was a state which itself had to be experienced. Replacing a work with a theoretical essay which could hang in its place was the most direct means toward this end; it was Conceptualism's most celebrated action, a gesture of usurpation of the predominant position of all the intellectual organizers who controlled and defined the Institution of Art. But, more importantly, it was the proposal of the final and definitive negation of art as depiction, a negation which, as we have seen, is the *telos* of experimental, reductivist modernism. And it can still be claimed that Conceptual art actually accomplished this negation. In consenting to read the essay that takes a work of art's place, spectators are presumed to continue the process of their own redefinition, and thus to participate in a utopian project of transformative, speculative self-reinvention: an avant-garde project. Linguistic conceptualism takes art as close to the boundary of its own self-overcoming, or self-dissolution, as it is likely to get, leaving its audience with only the task of rediscovering legitimations for works of art as they had existed, and might continue to exist. This was, and remains, a revolutionary way of thinking about art, in which its right to exist is rethought in the place or moment traditionally reserved for the enjoyment of art's actual existence, in the encounter with a work of art. In true modernist fashion it establishes the dynamic in which the intellectual legitimation of art as such — that is, the philosophical content of aesthetics — is experienced as the content of any particular moment of enjoyment.

But, dragging its heavy burden of depiction, photography could not follow pure, or linguistic, Conceptualism all the way to the frontier. It cannot provide the experience of the negation of experience, but must continue to provide the experience of depiction, of the Picture. It is possible that the fundamental shock that photography caused was to have

provided a depiction which could be experienced more the way the visible world is experienced than had ever been possible previously. A photograph therefore shows its subject by means of showing what experience is like; in that sense it provides "an experience of experience," and it defines this as the significance of depiction.

In this light, it could be said that it was photography's role and task to turn away from Conceptual art, away from reductivism and its aggressions. Photoconceptualism was then the last moment of the prehistory of photography as art, the end of the Old Regime, the most sustained and sophisticated attempt to free the medium from its peculiar distanced relationship with artistic radicalism and from its ties to the western Picture. In its failure to do so, it revolutionized our concept of the Picture and created the conditions for the restoration of that concept as a central category of contemporary art by around 1974.

[1] Editor's note: The present text is an adaptation of the essay by the same name first published in the exhibition catalogue *Reconsidering the Object of Art: 1965–1975*, Anne Goldstein and Anne Rorimer (eds.), Los Angeles, Cambridge (Mass.) and London 1995.

[2] Cf. Thierry de Duve's discussion of nominalism, in *Pictorial Nominalism: On Marcel Duchamp's Passage from Painting to the Readymade*, trans. Dana Polan with the author, Minneapolis 1991.

[3] Friedrich Nietzsche, "Ecce Homo," in *On the Genealogy of Morals and Ecce Homo*, Walter Kaufmann (ed.) and trans. Kaufmann and R.J. Hollingdale, New York 1967, p. 290.

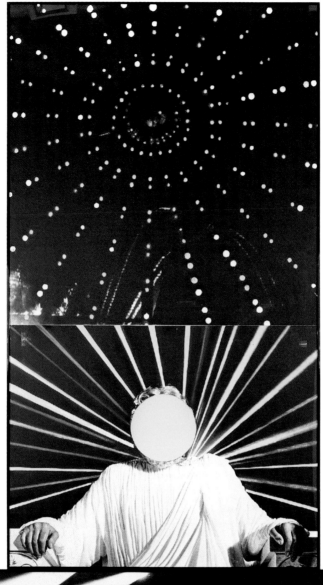

John Baldessari, Three Types of Light, 1988

Sam Samore, Allegories of Beauty, 1996

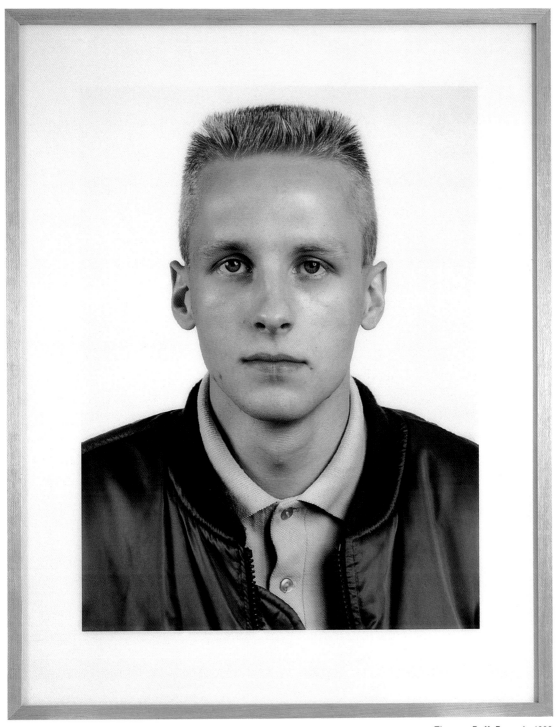

Thomas Ruff, Portrait, 1990

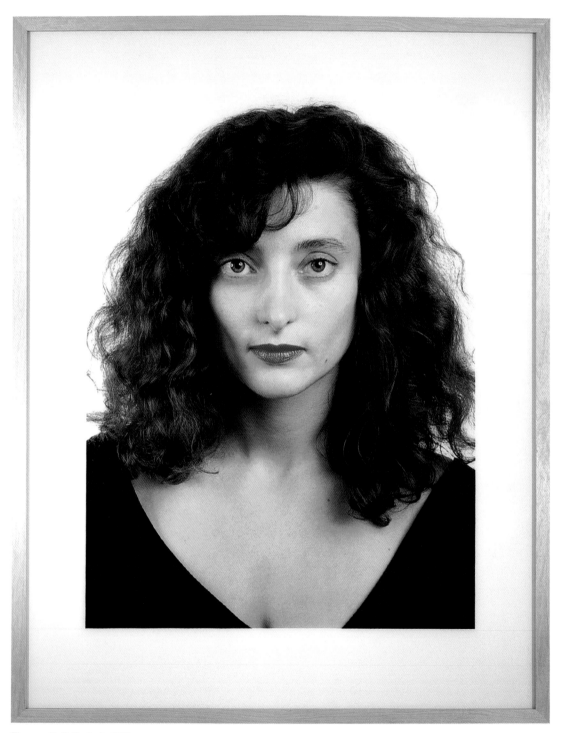

Thomas Ruff, Portrait, 1989

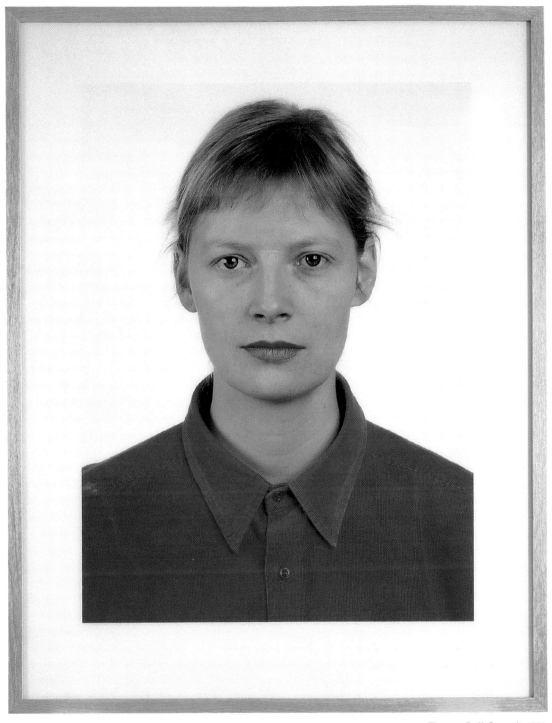

Thomas Ruff, Portrait, 1990

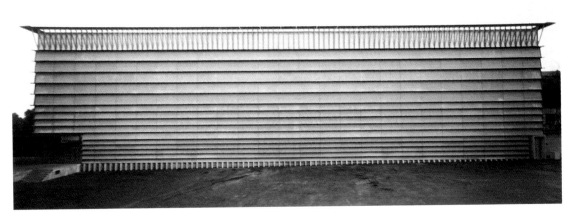

Thomas Ruff, Ricola Laufen, 1991

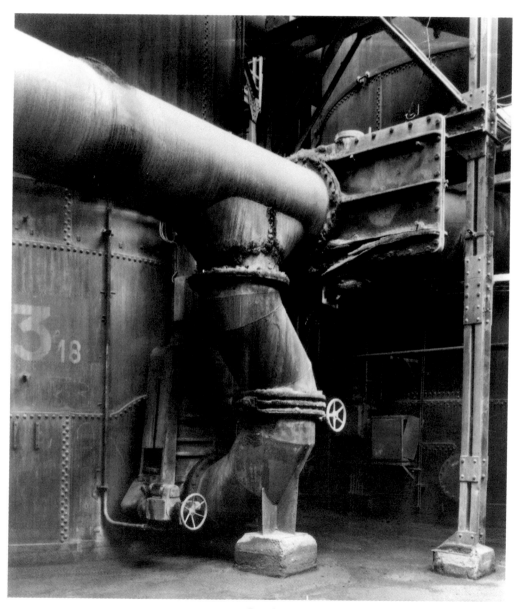

Bernd and Hilla Becher, Tubes, Völklingen, Saarland, 1986

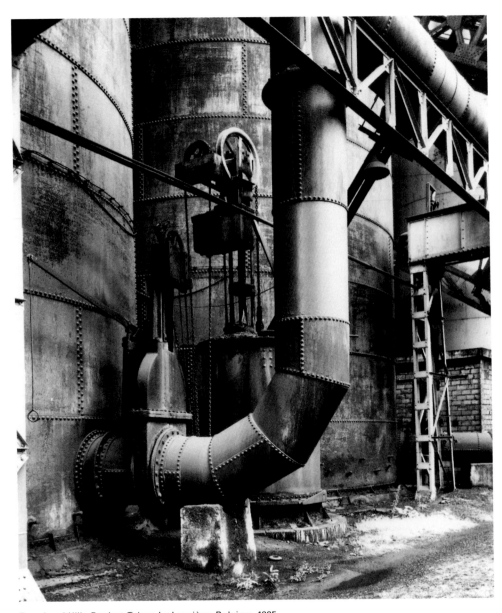

Bernd and Hilla Becher, Tubes, La Louvière, Belgium, 1985

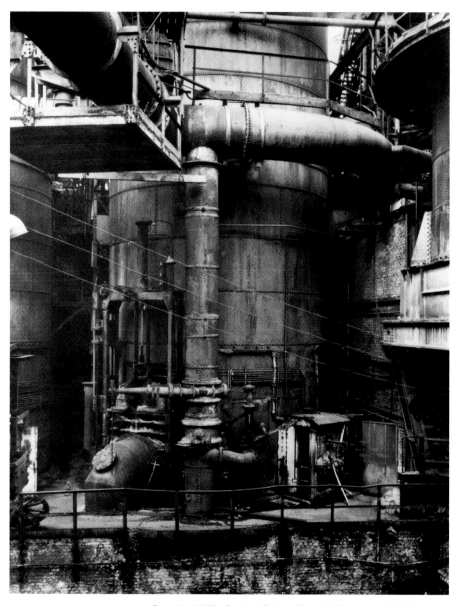

Bernd and Hilla Becher, Tubes, Chareloi-Damprémy, Belgium, 1986

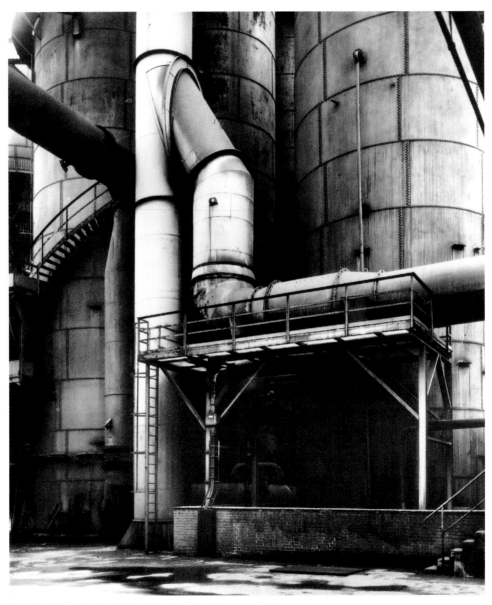

Bernd and Hilla Becher, Tubes, Ilseder Hütte, Hanover, 1984

Holger Liebs

The Same Returns
The Tradition of
Documentary Photography

"In the same issue there was also a picture of a champion
swimmer being massaged after a contest.... [She] lay on a bed,
naked on her back, one knee drawn up in a posture of sexual
abandon, the masseur standing alongside resting his hands on
it. He wore a doctor's gown and gazed out of the picture as
though this female flesh had been skinned and hung on a meat
hook. Such were the things people were beginning to see at
the time, and somehow they had to be acknowledged, as one
acknowledges the presence of skyscrapers and electricity."

Robert Musil, *The Man Without Qualities,*
trans. Sophie Wilkins and Burton Pike, London 1995, pp. 57–58

It was 1930 when press photographer Dr. Erich Salomon shot
what is probably his most famous picture: gentlemen at a round table
nodding off to sleep, divested of their dignity by overwhelming fatigue: it
is a political conference in The Hague at one o'clock in the morning. The
illustrated press, then at the height of its power and influence, was eagerly
lying in wait for just such snapshots. And Robert Musil had published the
first thousand pages of his novel *The Man without Qualities* whose seduc-
tive slogan reads "The Same Returns"[1]—Musil's stoical global formula for

an indifferent, vacuous age shattered by the habits of visual perception. New technical media of reproduction ("photographs"), the revolution of the social fabric ("electricity") and rampant urbanism ("skyscrapers") suddenly entered the socio-political field of vision. And not even blissfully snoozing statesmen or cold-eyed masseurs[2] could rest assured of their skins.

The photographers of New Objectivity registered these changes with seismographic precision: Erich Mendelsohn in *Amerika. Bilderbuch eines Architekten* (America. An Architect's Picture Book, 1925), Albert Ranger-Patzsch in *Die Welt ist schön* (The World is Beautiful, 1928), or August Sander in *Antlitz der Zeit* (Face of Our Time, 1929). What Musil, almost groaning, called "such things"—the chance contingencies of the photograph, its merciless neutrality that records every single detail, no matter how insignificant, and its chilling gaze—was welcomed elsewhere with enthusiastic acclaim. By Renger-Patzsch, for example, who praised the realism of photography for the "magic of its material". Where Musil fatalistically conceded the existence of skyscrapers and pylons, which undoubtedly he knew through photographs, as the signature of the times, Renger-Patzsch reveled in the richly nuanced play of metal surfaces (in his essay "Ziele"/"Goals", 1927): "…the rigid linear look of modern technology, the airy metal mesh of cranes and bridges, the dynamics of 1000-hp machines."

Both the critical writer and the euphoric photographer were referring to the same thing: a form of visibility that is only made possible by photography. To describe this, Walter Benjamin coined the term "unconscious optics": "Evidently a different nature opens itself to the camera than opens to the naked eye."[3] Close-up, blow-up, depth of field, precision of detail—since the 1920s, photography has opened up spaces that previously existed only in dreams or at most in an oneiric waking state but had certainly never been consciously seen, let alone reproduced.[4] The camera, Benjamin says, is like an anatomist; it penetrates the cellular

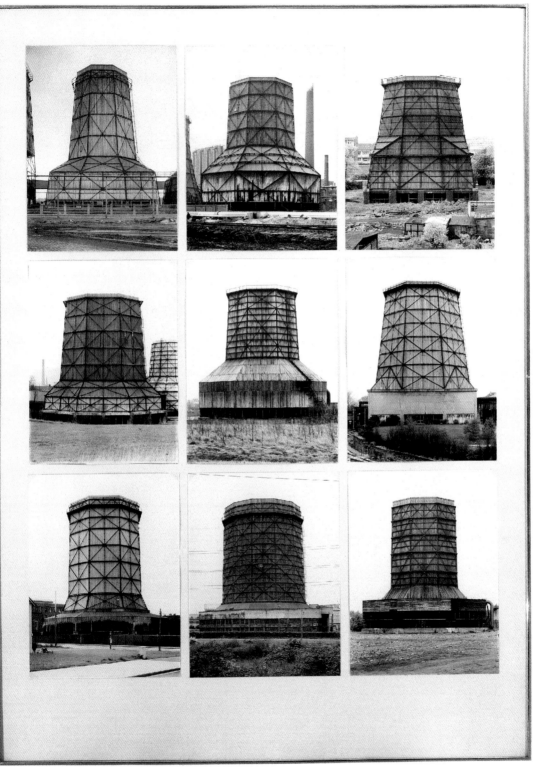

Bernd and Hilla Becher, Cooling Towers, 1976

structure of things that would otherwise remain unconscious and defini-
tively demonstrates that the relationship between technology and magic
is an inescapably historical variable. Karl Blossfeldt's ostrich ferns, which
remind Benjamin of a bishop's staff, are shown in details enlarged up to
45 times. The human eye could never plunge so deeply into the floral
microcosm. It is no accident that photo-journalists and the champions of
"New Objectivity"—above all the now famous triumvirate, Renger-Patzsch,
Blossfeldt and Sander—were compared to surgeons and, in fact, de-
scribed themselves as such.

 The idea that photography and anatomy, a scientific discipline
of the 19th century, uncover and expose the essence of things became a
recurring metaphor of modernism. "As in comparative anatomy, which is
necessary to an understanding of nature and the history of organs, this
photographer has conducted comparative photography," Alfred Döblin
writes about Sander in 1929. "Anatomically speaking, the blast furnace
corresponds to ... a body without skin. Its form is defined by the inner
organs, the veins, the skeleton," Bernd and Hilla Becher wrote about their
industrial photography as late as 1990. In mediating between the technical-
ly generated image and nature, documentary photography has repeatedly
resorted to the metaphor of the veracity of vivisection and has described
its effects in the revamped terms of scientific strategy. The documentary
approach was always held to be capable of "exposing" the "essence" of a
thing (Barthes).

 Georges Cuvier's *Leçons d'anatomie comparée* (Lessons on Com-
parative Anatomy, 1800-05) delivered a sort of the blueprint for this meta-
phor. In his analysis of organic life, Cuvier no longer studied the morpho-
logical variables of natural history, such as shape, size, order and quantity,
but penetrated the body itself with his dissecting knife. According to
Foucault, he subordinated the disposition of the organs to the sovereignty
of function.[5] This has served as the point of departure for the topos of
the modern edifice as a living organism whose functional structures are

The idea that photography and anatomy, a scientific discipline of the 19th century, uncover and expose the essence of things became a recurring metaphor of modernism.

to be visible. In his manifesto *Towards a New Architecture* (1923), Le Corbusier declared American grain silos to be the archetype of the engineering arts, the very embodiment of the creative idea of a living organism, and factories, the soothing firstborn of the new era.[6] Anonymous buildings, captured by the cameras of unknown photographers, illustrate Le Corbusier's polemical essays. The architectural or photographing individual is no longer of relevance, but only the technically generated form, the structure and the construction.

The documentarists wanted to devise a typology of the machine age. They are indebted not only to the tradition of the dissecting arts; their models also include Johann Wolfgang von Goethe's plant morphology and Carl von Linné's classical natural history with all the classifications, typologies and series of tableaux. For the Bechers as well, it would seem that these models provided a scholarly guarantee of the integrity of the modern medium. In actual fact, aesthetic decisions are also involved as substantiated by the researches of both Goethe and Linné. The "delicate empiricism"—to use Benjamin's epitaph for the positivist efforts of New Objectivity—is always saturated with the ocean of aesthetic mentalities, but the renunciation of an artistic signature and iconographic references was intentional. The objective was the mastery of technical equipment and not notions of "creative" photography as propagated by the graphic arts. Photographers felt closer to photographic journalism and films than to painting. In any case, the rendezvous between technology and nature establishes its own levels of artificiality. Even the most

understated of Blossfeldt's scouring rushes is more than a mere plant; enlarged to gigantic proportions, it is transformed into a monumental column.[7] Every photograph is a construction that shows the formal imprint of an aesthetic will.

This also applies to the relationship of the New Objectivists to their heirs. The cult of technology that prevailed in the 1920s and was burlesqued by Brecht in his poem "7000 Intellectuals Worship an Oil Tank" reveals an entirely different aesthetic approach from that of the electronic age of information. The latter has made it possible to produce semi-scientific serial, archaeological studies of a vanishing industrial architecture. Nonetheless, a tradition has emerged of staged non-atmospheric detachment, of tidy, cleaned-out sites, of emptiness filled with objects. Even Bernd and Hilla Becher's series are monuments of loneliness and melancholy, like Eugène Atget's pictures long before them: deserted, abandoned in-between spaces that only the camera can capture. They photograph their half-timbered houses, bulbous gas tanks, blast furnaces, cooling towers and derricks at mid-height with full-plate cameras, exposure times of up to 60 seconds, and diffused light. The procedure is entirely indebted to the technicity of the subject and the equipment. Yet, even so, the rationale of the auratic work of art oozes out of every pore: when a gas tank looms into a picture head-on like the very coliseum itself, it radiates the energy of a sacred monument.

The great portraitists are mythologists, Barthes tells us, and Thomas Struth's hierarchical, selective and highly differentiated portraits of families may well go down in history as a record of everyday mythology at the end of the 20th century. The Becher students, Candida Höfer, Thomas Struth, Thomas Ruff, Andreas Gursky, and others, have captured new levels of artificiality in urban zones that are rapidly succumbing to facelessness, like the man without qualities. Full living rooms, empty streets; Struth gives visual voice to Richard Sennet's theorem of the "disappearance and end of public space." His linear perspective—a tradition that photography

pursues with other means — is merely the civilized crust with chaos see-thing underneath; the Greek agora has finally and forever given way to agglomerations of peripheries. The homeless, placeless masses symboli-cally congregate in the semi-public chambers of museums, clinging to the illusion of the bourgeois mode — disguise and differentiation.

Seen from above, even the most horrendous modernist architec-ture becomes bearable. Le Corbusier's *Plan voisin* (1922), the utopia of Paris as a city of skyscrapers, would have been an asphalt desert as seen from within, but from a bird's-eye view the "free play of bodies under the sun" actually becomes plausible. Andreas Gursky's photographs show a preference for extended horizons, with a touch of the cartographer's gaze. "As if one's eyelids had been cut off"—as Kleist remarks in front of Caspar David Friedrich's paintings. Gursky is a holist. Whether he shoots modernist grids or the rhythmical undulations of a crowded stock market, his tableaux always present a composed totality not unlike paintings. Thomas Struth's series, on the other hand, seem to have exorcised all subjectivity. Reality, they seem to confirm, is photographically structured, and space is always medially invaded, like the site of a crime. The human being has vanished only to be replaced by the phantom image chalked on to the site. Ruff magnifies the documentary metaphor until it becomes an absolute. The elimination of qualities is like fog that has first swallowed the medium, then the photographer and finally all of visible reality. In the end there is pitch-black night. Visible are only the silhouettes of nocturnal scenarios under crystal-clear starry skies. It is a chilling world. The technical eye of a remote-controlled surveillance camera rotates in isolation — and no longer even finds a tin can in outer space. Supernova, the rings of Saturn, solar eruptions? The same returns.

Translation Catherine Schelbert

[1] Translator's note: "Seinesgleichen geschieht" is the heading of part 2 in Musil's novel, *Der Mann ohne Eigenschaften (The Man Without Qualities).*

[2] "That is the paradox: how can one have an *intelligent air* without thinking about anything intelligent, just by looking into this piece of black plastic?" Roland Barthes, *Camera Lucida*, translated by Richard Howard, London 1984, pp. 111–113.

[3] Walter Benjamin, "The Work of Art in the Age of Mechanical Reproduction" in: *Illuminations*, translated by Harry Zohn, New York 1969, pp. 236–37.

[4] In this tradition of terminology Thomas Struth refers to the "unconscious optics" of his cityscapes. The photographed scenes are deserted, intensely perspectival and tend to treat urban situations rather than architectural objects.

[5] Michel Foucault, *Les Mots et Les Choses*, 1966.

[6] The Bechers own a first German edition *(Ausblick auf eine Architektur,* 1922).

[7] "Genrefotografie: Der Bildhauer Kalimachos erfindet beim Anblick einer Akanthuspflanze das korinthische Kapitäl." (Genre photography: On seeing an acanthus plant, the sculptor Callimachus invents the Corinthian capital.) Walter Benjamin, *Das Passagen-Werk*, Frankfurt am Main 1982, vol. 2, p. 835.

Peter Fischli / David Weiss, The Accident, Sausage Series, 1980

Peter Fischli / David Weiss, In the Carpet Shop, Sausage Series, 1980

Peter Fischli / David Weiss, Untitled, Quiet Afternoon, 1984/85

Peter Fischli / David Weiss, Roped Mountaineers, Quiet Afternoon, 1984/85

Peter Fischli / David Weiss, The Fart, Quiet Afternoon, 1984/85

Bice Curiger

When Borders Blend, Where is the Art?

Indecisive moments, moments of inertia

In their very first joint venture, the notorious *Sausage Series* of 1979, Peter Fischli and David Weiss demonstrated how much fun it is to work as a pair. They played with food and casually came up with the on-going agenda of their utterly disarming art. Subsequently, the question of whether art can be produced from teamwork was repeatedly woven into their output, confronting not only an art public but also a larger one, with the additional question of how two people go about taking one photograph. No matter how you look at it, a camera still has only one viewfinder and one shutter release.

In this respect, the title of their 1984/85 series of photographs, *Quiet Afternoon*, is as harmless as it is guileful. Explicitly declared as the exploitation of a few leisure hours, the pictures are the unassuming blossoms of a flourishing togetherness, of a stimulating being-by-them-selves within the cosy security of their own four walls. There is no sense of the hunt, no adventurous spirit wafting towards us, no handstand at ten-thousand feet above sea level, no fearless gaze into the lion's gaping maw, nor any sensations despotically commanding attention.

That it is anti-heroic is the very least that might be said about the photography of Fischli and Weiss. Yet the pictures in *Quiet Afternoon* radiate the daring prowess of two hunters of happiness courageously

> The pressing of the shutter release, the taking of
> the photograph, does not count for much more than all the
> other acts in the long chain of decisions.

venturing into uncertain territory. What looks at first sight like a hodge-podge of bizarre and shabby still-lifes is, in fact, a series of audaciously fragile compositions that threaten to collapse at any moment.

Playful and dreamy dangers inspired by an ingenuous wonder at the miracles and laws that make the world go round, these pictures are tantamount to a poetic compendium of all photographic endeavor. While we, as spectators, become extraterrestrial beings who, in a kind of slow-motion deceleration gaze from outer space at that infamously famous something that is photography, that great *momentum,* that *decisive moment,* as Henri Cartier-Bresson titled his famous book. In the case of Fischli and Weiss, such a moment exists only in the build-up, in the invocation of a redolent "before." In their own words: "Balance is most beautiful of all/Just before the fall."

Discreet drama camouflaged as an array of offbeat circus tricks in domesticated format, Fischli and Weiss's *Quiet Afternoon* bursts into a bouquet of acrobatic tricks that act like parables. There is this inertia of a truly quiet afternoon, this prolongation — the actual collapse of the con-struction — as an artistically delineated slice of time. And having cleverly uncoupled themselves from the permanent social crossfire of an acceler-ated world by carving out a temporary interstice, the two devote them-selves to breathing meaning into their game *de deux.* It speaks of inspired idleness, of "stolen" time, of flights of fancy based on detritus, on the cast-offs of the rest of the world's bustling activity.

The pressing of the shutter release, the taking of the photograph, does not count for much more than all the other acts in the long chain of

decisions. In the final analysis, the picture is a stratified record of many fundamental moments in which one thing leads to another, in which mental concentration is honed, culminating in a title that is the result of second looks and evaluations. The quiet dialogue in which this art duo is engaged yields a parable for the precarious essence of communication. And it is, moreover, a set piece for the newly enacted role of the artist in the plural, of Fischli and Weiss, whose spectrum of insights is determined by something akin to a junkyard empiricism.

The world view of Fischli and Weiss regenerates a loss of focus by allowing an obsolete artistic canon (the roles of the photographer, the artist, and all the clichés associated with the readymade and the *objet trouvé*) to collide with an actively lived collective life (even artists occasionally use colanders and their wives wear stiletto heels); it is as if *bricolage*, experiments with objects one ordinarily blocks out of perception —those things now defunct, the debris of this world or, as Thomas Struth says, the "unconscious places"—could open the heavenly gates.

Dabbling and daring

Today's artists have, as they say, breathed life into photography. One who addressed the medium early on with a delight unfettered by misplaced respect (though he later behaved like a highly sophisticated darkroom *enfant terrible*) is Sigmar Polke. The preliminaries were negotiated in humorous poses, demonstrating how beautifully photography can lie, as in, for example, *The Double, The Pasture Grown Hollow Only Because of Me, The Blanket That Always Falls in the Contours of the Female Figure*, all from 1968. Polke's satirical attitude was aimed primarily at conceptual art's documentary use of photography, at deconstructing its exaggerated gravity and its half-hearted tautological thrust.

Withdrawing only to become deeply involved from the outside, Sigmar Polke jettisoned the countless fetishized procedures that accompanied the making of a picture in both painting and photography. Polke's

Sigmar Polke, Untitled, 1968–90

use of photography is so unorthodox that the *single* moment of the shot, when the shutter release is pressed, when the targeted spoon is dangling on the string and the cucumber is casting its shadow, is condensed into a gossamer fog of time that lies evenly over the other temporal elements in the picture: from threads of dust, scratches, the exaggerated grain, and all the consequences of the "mistakes" in working with the camera, like extreme over-, under-, or double exposures, to "mistakes" made in the darkroom, such as interrupting or heightening the process of development, or adulterating the developer, one that is preferably of questionable origin to begin with.

Looking at a Polke photograph not only means looking out of the imaginary pictorial window but also into the developer, into the hypersensitive skin with its grainy coating and the silver that contains the magic powers of oxidation. It is as if the picture, on making contact with the mind, had liquefied and dissolved into a phantasmagoric chain of associations rendered by chemical processes. In the pictorial shine of the mechanisms that ignite our imagination, we are rewarded with views of a micro- and macro-world, of atom and outer space, of past, present, and future, of quotidian remnants of mythical dimensions and mundane puffballs of dust, of microbes and cosmic light. These photographs have on occasion been known to adopt an appearance of harmless experimentation but it is the entire spectrum of experiential energy from his photography that informs the expansive "alchemistic" horizon in his painting.

Polke's significance lies in the fact that whatever medium he uses undergoes rediscovery and quickening as an instrument of thought and a generator of pictures. He immediately devises a strategy for a kind of *aktionist* observation to liberate the potential that is imprisoned within and screaming to be let out. Thoughts are unlimited and Polke basically allows the medium far greater faculties than ordinarily voiced and offered. Thus, results come flying out that can indeed be called "mind blowing." Under the cover of photography, Polke uses such devices as radiation, uranium on

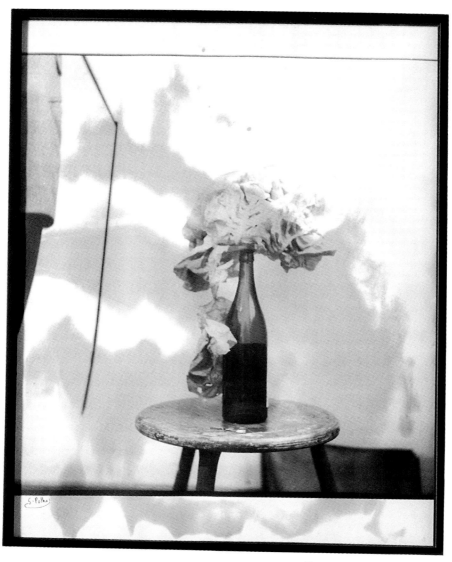

Sigmar Polke, Untitled, 1968–90

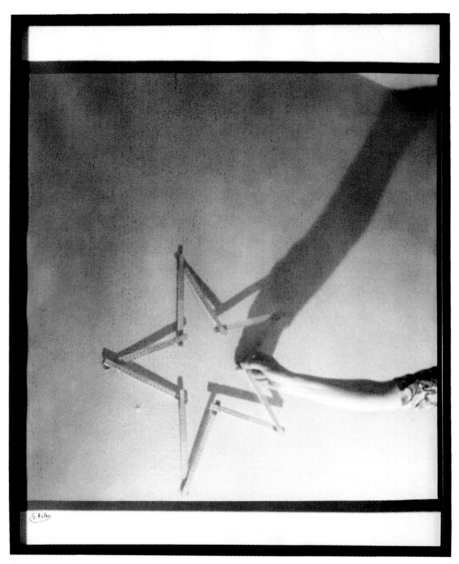

Sigmar Polke, Untitled, 1968–90

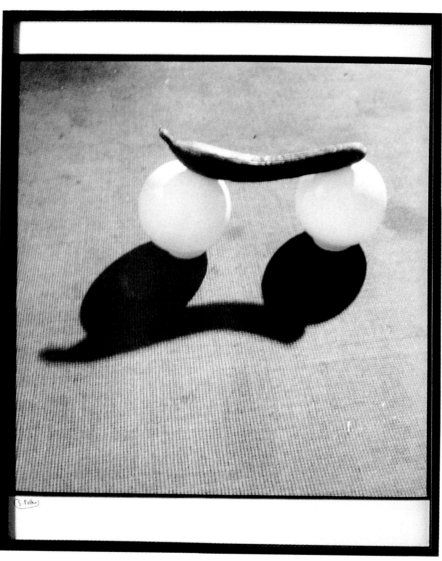

Sigmar Polke, Untitled, 1968–90

Andreas Gursky, Brasilia, Assembly Hall, 1994

Ektachrome, or soot on glass to ceaselessly challenge and explode the limits of matter and art.

The skin as mirror and the form that tends to content

For decades, underground artists have engaged in an intimate form of photography, taking pictures in close proximity to the human body. The uninhibited surrender of the body to the detached gaze of the camera in Andy Warhol's films such as *Sleep,* (1963), *The Chelsea Girls,* (1966), *The Nude Restaurant,* (1967), and *Blue Movie,* (1968), was but the sign made flesh of a cool, urban variation on the pathos of liberation that characterized the times. Warhol's gaze reacted with a pointed lack of passion, "My mind is like a tape recorder with one-button erase." In 1966, he designed a record cover for the *Velvet Underground* with a large sticker of a banana attached to it, which could be peeled off with predictable pleasure. Warhol would occasionally put on make-up and don a wig. When he suffered his infamous gun wound, he flaunted his barely healed scars for Richard Avedon's camera, a photographer already well-versed in shooting models and miners.

Although the milieu appears to be the same, we suddenly find ourselves decades later gazing at entirely different, existentially bared skin in Nan Goldin's photography. "By the skin of one's teeth," "skinned alive" are expressions that come to mind when confronted with the commanding presence of Goldin's pictures.

While Warhol displayed exceptional foresight by directing his attention towards the "extra-painterly" issues that were to become factors of social upheaval, he still remained the mythomaniac. In contrast, it is Nan Goldin's declared desire to "tear down fictions" that reveal her unbroken faith in photography's ability to disclose reality.

When women proceeded to conquer artistic territory, they looked around for media that were not tainted with the male hegemony of the high art tradition of painting. What better place to embark on the study of one's

own skin than photography, with its fictionally pointed "nowness," its closeness to fashion and film, both of which emphasize the present. Cindy Sherman's tabula-rasa *rendezvous* with the camera has come up with a new pictorial meta-construction in a complex realignment of myth and reality.

Cindy Sherman and Nan Goldin both use photography with an immediacy and an involvement that relentlessly places the context of their own experience at the center of their art. They may look as if caught in passing, but Goldin's pictures, in which lighting and coloring are closely and precisely interwoven with the composition, reveal consummate skill and a highly refined sense of form. It is, in fact, this great care that comes into play at moments of stirring emotionality, when Goldin's tendency to embrace with attentive warmth the figure appearing in the lens of her camera, to wrap it in a protective cloak of dignity despite the vulnerability of its nakedness, infuses her pictures with such extraordinary loving affection.

The return of the painting as tormenting image

Photography, that relatively young but omnipresent medium, has recently induced several artists to deploy the very latest visual technologies for experimental "research" into the great and venerable heritage of historical art. Photographic formats have begun to encroach upon those of painting not in order to ennoble the medium but rather as a means of producing a kind of complex visual trap, capable of tapping deep-seated conditioning and testing almost atavistic reflexes. I am referring here to the tendency to read formal problems in relation to one's physical limitations, one's conditioning and one's perception, like a line traversing the picture plane or, more generally, the recognition that the magnetic pull of an abyss or a picture's expanding horizon is suggestive of depth and space.

Recent approaches have suddenly opened up uncharted territory in both photography and painting. In the composition and formal construc-

tion of his photographs, which are presented as illuminated displays, Jeff Wall seeks to achieve the stringency of composition that marks "old paintings." Despite all cultivation, his cogent, illuminated images flood the space of art with a tidal wave of accentuated social reality.

This also makes Andreas Gursky appear to be a guileful engineer specialized in the fusion of visual energy. Art in the throes of modernism may once have thought itself exempt from depicting reality thanks to the invention of photography, but the art of painting has since become mired in the fetish of pure abstraction and the structural refinement of a staggering self-referentiality. These are the issues that are highlighted by Gursky, especially when he works with a kind of double code in his large-format photographs. On the one hand, there is the close mesh of the artistically trained gaze that banks on the potent distinction between close-up and long shot as well as the slightly hypnotic effect of a repeated form; but there is also the highly sophisticated embrace of reality that efficiently catches the unwitting viewer off guard as it swoops down on sites ordinarily ignored by art: industrial production plants, highways, or recreational facilities.

The photograph *Brasilia, Assembly Hall,* 1994, is steeped in all the immeasurable ambivalence with which we approach modernism today. The aurora of spiritual renewal once associated with the place, Brasilia, was soon debunked as one of those shabby ceilings that are the quintessence of the abysmally ugly architecture of administrative buildings found the world over. The illuminated bodies with their finely chiseled lamella grid and dynamic patterns of bundled light are suffused with the inspiration of a painting and yet, they are really only an oddly offbeat fanfare for an audience that has already gone home.

Translation Catherine Schelbert

Mike Kelley, Ahh...Youth, 1991 (pp. 128–135)

135

Gerhard Richter, Triple Self-Portrait, standing, 1991

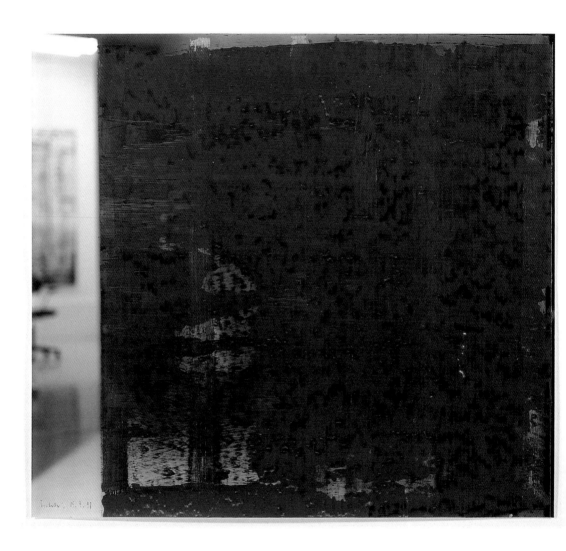

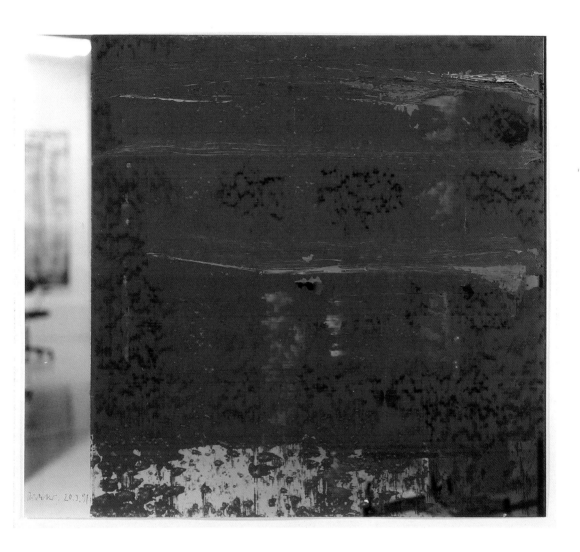

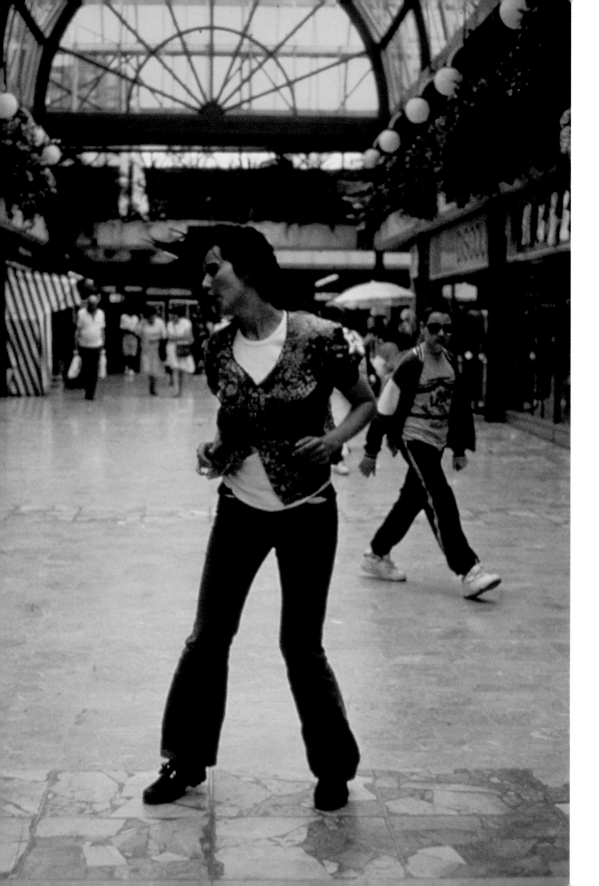

Jennifer Blessing

Notes on the Sacred
in Contemporary Art

Damien Hirst, With Dead Head, 1991

I am ten years old and have found an old, scallop-edged photo-graph. In it I see my grandfather as a young man, with a friend, both in white smocks, their arms around a withered old man between them. I try to determine where they might be going, since they are indoors, they are dressed; while the deeply tanned, wizened personage is hardly clothed at all. He is very thin, like Gandhi. Then I notice that the old man's feet do not quite touch the ground. The two young laughing medical students are holding up a cadaver.

"The sacred world is a world of communication or contagion, where nothing is separated and a special effort is required to remain outside the undetermined fusion. It could even be said that the profane state is the necessary prerequisite for abstraction of the object from the totality of being. Take the example of the corpse: it can be dissected and treated as an object of science only to the extent that it passes — even if this scandalizes the devout or superstitious — from the domain of the sacred to that of the profane."

Georges Bataille, "War and the Philosophy of the Sacred"[1]

Bataille lamented the absence of myth in modern life, which he saw as a kind of fall from grace that left modern man bereft of the experience of the sacred. In his examinations of "primitive" rituals involving human sacrifice and violence, he attempted to understand the communal bases of these activities, at first with an eye to recreating them, and later as a basis for his theoretical arguments for the reintegration (or perhaps disintegration) of the sacred into everyday life. The corpse is an example of an object taken out of context (outside its status as a container for a specific individual and those taboos attendant to that particular body), which is profaned, forced into banality, and maneuvered into disposability. A contrary operation occurs when the profane thing — the abject object — is recontextualized or invested with meaning and becomes sacred.

"And the profane object is not essentially something different from the *sacred*. In both cases there is simply a change of perspective."

Bataille[2]

Kiki Smith, Frozen Jars, 1991

On an independent adolescent visit to a grocery store that I do
not normally frequent, I pick up a large and curious piece of frozen meat
in order to identify it. Before I read the label, I recognize the rock hard,
oversized tastebuds on it and suddenly realize that I am holding a cow's
tongue. Until this moment, I had no idea that tongues were sold, or eaten.

> "St. Anthony, for instance, was allowed to disintegrate in
> the normal way, but his tongue remained 'red, soft, and
> entire'— an objet which aroused the veneration of Thérèse
> of Lisieux on a journey to Italy some six and a half centuries
> after his death."
>
> Vita Sackville-West, *The Eagle and the Dove*[3]

With his readymades, such as the 1917 *Fountain*, Marcel
Duchamp asserted that art would be created through a process of desig-
nation or nomination. The artist's function was to select an object, pre-
sumably chosen at random and specifically non-art, and then to change
the context in which it was understood, inserting it into the system of art
presentation and consumption, thus ultimately changing the terms of that
system. This gesture is classically interpreted as one that collapses the
boundaries between art and life. Perhaps it can be seen as a Bataillean
sacralization of the detritus of life *as art*, whereby debased, almost invisible

objects, are transformed. Is it a ritual akin to the liturgical demonstration of transubstantiation, in which wine and bread become the blood and body of Christ? Is not Duchamp's most famous readymade, the *urinoir*, now a venerated object, worshipped not only by the art market nor for the aura it takes on within the context of the museum, but as a sign of a communally shared belief system, at the least an emblem of a transcendental sense of humor?

> "... the sacred is only a privileged moment of communal unity, a moment of the convulsive communication of what is ordinarily stifled."
>
> <div align="right">Bataille, "The Sacred"[4]</div>

Paul McCarthy, Props/Objects: Donald Duck, 1995

At the opening of his 1960 exhibition titled "The Consumption of Dynamic Art by the Public Devouring Art," Piero Manzoni boils seventy eggs, marks each one with his inked thumbprint, and gives them to the

visitors to eat.[5] The remnants of the performance—those eggs that were not eaten, now rotten, or just their shells, each bearing the forensic trace of the artist and in being individually boxed and carefully couched in cotton—recalls the desiccated remnant of a saint's big toe.

> "If all physical contact calls to mind the act that establishes it (in an indexical relationship), every act calls forth as well, and imperatively, the proper name of the *actor:* he who left some of his blood on this linen sheet ..."
>
> Georges Didi-Huberman, "The Index of the Absent Wound (Monograph on a Stain)"[6]

Manzoni and the other "Neo-Dada" artists of the late 1950s took many of their cues from Duchamp. In their work, a performative gesture leaves a residue or relic, sometimes quite ephemeral, of the act of creation. In 1919, Duchamp bottled Parisian air. A little more than forty years later, Yves Klein produced *Zones of Immaterial Pictorial Sensibility,* and Manzoni sold *Bodies of Air* and *The Artist's Breath,* as well as his shit. Manzoni planned to produce vials of his blood. Irony notwithstanding, these conceptual works depend upon a kind of faith in the meaning of the artist's performances. The objects that are left behind become the source of scholastic arguments about authenticity, like Veronica's veil or the Shroud of Turin. But does it finally matter whether it is blood or ketchup? Or, if it is shit or pineapple in those cans? Do we really think that a splinter of wood is a piece from the true cross? Does it matter to the fetishist if his shoe is just a shoe? No ritual has the same meaning outside of its context, nor do its objects.

"Let us recall that the historic impetus that rendered the shroud of Turin visible — or more precisely, figurative — is found in the history of photography."

Georges Didi-Huberman, ibid.

Annette Messager, Hands, My Trophies, 1987

A television reporter asks a man whose apartment building has just been destroyed by fire whether he was able to salvage anything from the wreckage. "The only thing I saved was a photograph of my grandmother. I'm really glad I got it, because it couldn't be replaced. This is the only photograph of her — and nobody else has a copy."

"... neither image nor reality, a new being, really: a reality one can not longer touch."

Roland Barthes, *Camera Lucida*[1]

Just as a relic is a sacred fragment of a historical being, the photograph, through its indexical relationship to a subject before the lens, is a kind of proof of that subject's existence. The trajectory of the performance variety called Body art is documented by canonical photographs,

such as the 1921 image of Duchamp tonsured with a star shaved out of the hair on his skull: or, Klein's *Leap into the Void* of 1960; or the image of Chris Burden's hands bearing the literal stigmata of nail holes from his 1974 performance *Trans-fixed*. In the 1970s, the artist's body is presented as the site of a wound, which must be demonstrated to the viewer, whose doubt echoes Thomas's — unless he saw and touched, he would not believe.[8] The wound is itself a trophy of proof, of the existence of an actor, the one who is acted upon, and whose wound leaves its trace.

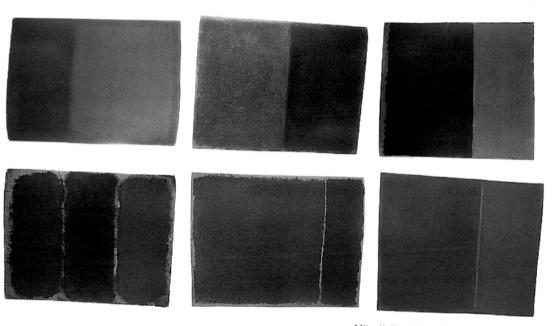

Mike Kelley, More Tragic..., 1985/86

At the age of five, my most beloved toy is an orange felt teddy bear with a deeply frowning plastic face. One day, furiously angry at my mother, I partially sever its head when I hit it over my knee. My mother sews the head back on, but now, with heavy black stitches around its neck, it looks like Frankenstein, and is a constant reminder of my guilt.

"In Photography, the presence of the thing (at a certain past moment) is never metaphoric; and in the case of animated beings, their life as well, except in the case of photographing corpses; and even so, if the photograph then becomes horrible, it's because it certifies, so to speak, that the corpse is alive, as *corpse:* it is the living image of a dead thing."

<div style="text-align: right">Barthes, ibid.</div>

For Barthes, some photographs contain a punctum, a stigmatum, something about them, perhaps a detail, that pricks the mind, provoking a tiny shock. The punctum of a photograph is not necessarily the same for each individual: "it is what I add to the photograph and *what is nonetheless already there.*"[9] Barthes is most wounded by a picture of his mother as a young girl, which he stumbled upon shortly after her death. He is struck by the experience of seeing her as she was before he was even born, before he was the child of the girl, now dead. Children have always been a favorite subject of photography, which pathetically attempts to capture their fleeting youth, to make it eternal. These images are charms, sacred talismans to ward off our impending mortality. Perhaps nothing is more disturbing than the profanation of ideals of childhood. And yet, is not Bataille's pornographic novel, *Story of Eve,* a book generated by unconscious memories of the author's childhood, rather than a theological tract for a century in which only sexuality vies for a hold on the sacred?[10]

"Photography literally kills movement, fixing it, without the possibility of repentance. It puts us face to the horror of time reduced to a quarter of a second: it is a recreation devoted to truth and to deception, like in taxidermy..."

<div style="text-align: right">Annette Messager[11]</div>

Janine Antoni, Momme, 1995/96

In a film by Alain Cavalier, the future Saint Thérèse and her fellow sisters speak of Christ as a boyfriend, a husband, a child, a jilting lover who has abandoned them.[12] They are the wives of a sailor who is perpetually out at sea. They construct the perfect lover of their imaginations and feel a perfect yearning. They construct a life that is determined by desire: this is the lace I weave as I wait for Him; this is the abject task that I perform, the deprivation that I suffer, which proves my love for Him; this is the self-inflicted pain that I endure in order to make myself worthy of Him; this is the death that I seek so that we may be united.

> "For Death must be somewhere in a society; if it is no longer
> (or less intensely) in religion, it must be elsewhere; perhaps in
> this image which produces Death while trying to preserve life."
>
> Barthes, ibid.

Before photography, the memory of a loved one might be preserved in an image (a portrait) or an object (a death mask, a lock of hair). Tokens of the departed are both exhilarating for their tantalizing promise of access, and horrible because of the inevitable failure of that promise. Even desire for the body of the living includes a kind of mourning, encom-

passing as it does a loss (or necessity umbilically linked with disgust, the inescapable outcome of intimacy, and hence familiarity first glimpsed) and yet the profanity of this body must be overcome, must be redeemed to remain the sacred vessel of the beloved. Then love encompasses the body's abjection.

> "The term *privileged instant* is the only one that, with a certain amount of accuracy, accounts for what can be encountered *at random* in the search; the opposite of a *substance* that withstands the test of time, it is something that flees as soon as it is seen and cannot be grasped. The will to fix such instants, which belong, it is true, to painting or writing is only the way to make them *reappear*, because painting or poetic text *evokes* but does not *make substantial* what once appeared. This gives rise to a mixture of unhappiness and exultation, of disgust and insolence; nothing seems more miserable and more dead than the stabilized think, nothing is more desirable than what will soon disappear."
>
> Bataille, "The Sacred"[13]

[1] Georges Bataille, "War and the Philosophy of the Sacred," in *The Absence of Myth: Writings on Surrealism*, Michael Richardson (ed. and trans.), London and New York 1994, p. 114. This essay first appeared in *Critique*, no. 45, 1951.

[2] *Ibid.*, p. 115.

[3] Vita Sackville-West, *The Eagle and the Dove. A Study in Contrasts: St. Teresa of Avila, St. Thérèse of Lisieux*, London 1943, p. 12.

[4] Georges Bataille, "The Sacred," in *Visions of Excess: Selected Writings, 1927–1939*, Allan Stoekl (ed.), trans. by Allan Stoekl with Carl R. Lovitt and Donald M. Leslie, Jr., Minneapolis 1985, p. 242. This essay first appeared in *Cahiers d'art*, no. 14, 1939, pp. 47-50.

[5] A later version of this work was titled *Communion with Art*.

[6] Georges Didi-Huberman, "The Index of the Absent Wound (Monograph on a Stain)," trans. by Thomas Repensek, in *October*, no. 29, Summer 1994, p. 68.

[7] Roland Barthes, *Camera Lucida: Reflections on Photography*, trans. by Richard Howard, New York 1982, p. 87. Originally published in 1980 as *La chambre claire*.

[8] The apostle Thomas quoted in John, XX, 25: "Unless I see in his hands the print of the nails, and place my finger in the mark of the nails, and place my hand in his side, I will not believe."

[9] Barthes, *Camera Lucida*, p. 55.

[10] Bataille, *Story of Eve*, trans. by Joachim Neugroschel, San Francisco 1987. Originally published pseudonymously in 1928 as *Histoire de l'oeil*.

[11] "Annette Messager, ou la taxidermie du désir, entretien avec Bernard Marcadé," in *Annette Messager: comédie, tragédie, 1971–1989*, exhibition catalogue, Musée de Grenoble (ed.), Grenoble 1989, p. 11: "La photographie tue littéralement le mouvement, en le fixant, sans repentir possible. Elle nous met face à l'horreur d'un temps réduit au quart de seconde; c'est une recréation vouée à la vérité et à l'imposture, comme la taxidermie ... "

[12] *Thérèse* directed by Alain Cavalier in 1986.

[13] Bataille, "The Sacred," p. 241. For his use of the expression "privileged instant," Bataille cites Emile Dermenghem, "The Instant in the Works of the Mystics and Some Poets," in *Mésures*, no. 1, July 1938.

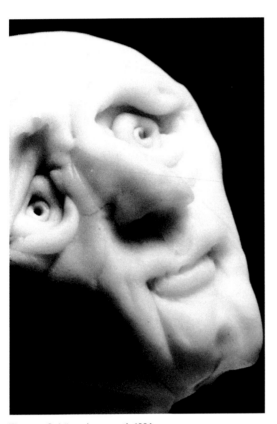
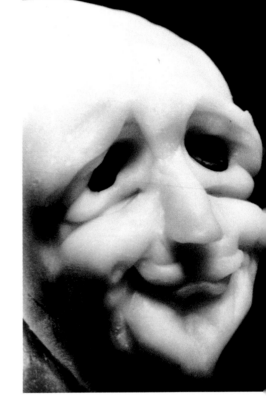

Thomas Schütte, Innocenti, 1994

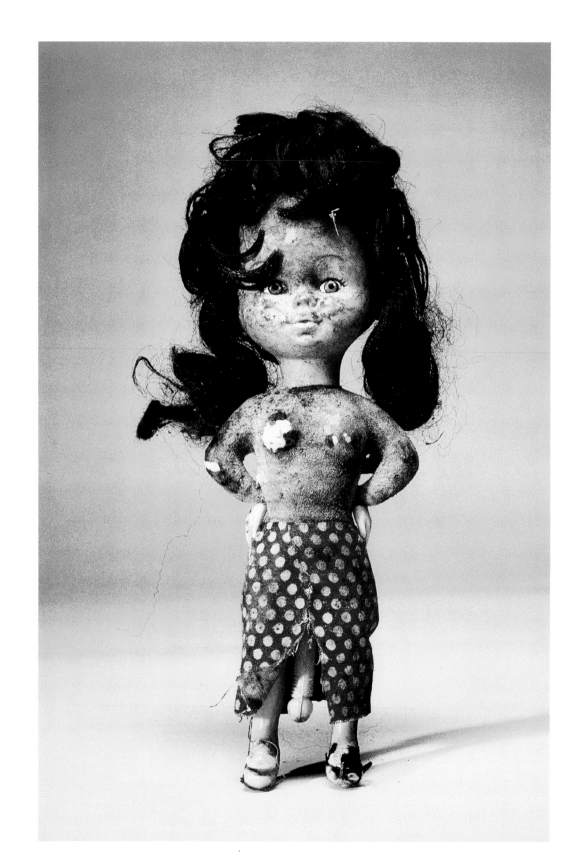

Marina Warner

Playacting, Chimerae and the Late Grotesque

In a conversation reported by Francisco de Hollanda around 1540, Michelangelo took up a phrase that the poet Horace had let drop in passing. In the midst of his repudiation of the grotesque, Horace had written: "Painters and poets have always had the prerogative to dare anything. We know it, and both demand it and grant the same licence. But not so far as to unite the mild with the savage or that snakes should be coupled with birds, lambs with tigers."[1]

Replying to Hollanda's question about monsters and hybrids in art, Michelangelo quoted Horace's aesthetic axiom, *quodlibet audendi potestas*, and formulated a forceful defence of the imaginary and the grotesque in the name of reason itself: "But if, in order to observe what is proper to a time and place, he exchange the parts or limbs (as in grotesque work which would otherwise be very false and insipid) and convert a griffin or a deer downwards into a dolphin or upwards into any shape he may choose,...this converted limb, of lion or horse or bird, will be most perfect according to its nature; and this may seem false but can really only be called ingenious or monstrous. And sometimes it is more in accordance with reason to paint a monstrosity (to vary and relax the senses and the object presented to men's eyes, since sometimes they desire to see what they have never seen and think cannot exist) rather than the ordinary figure, admirable though it be, of man or animals."[2]

ul McCarthy, Girl with Penis, 1992

This passage still breathes a tranquil humanist sense of the segregation of the monstrous from the human. But Michelangelo's wilful reading of Horace's critique as endorsing the antinomian tendency in creativity, foreshadows the future development of the grotesque and points forward to contemporary artists who have taken the prerogative of daring as the definition of art's function. And the new technical developments of film media, from Cibachrome to computer-generated simulation, have made it possible to materialise "chimerical beings," combinatory fantasies and new, monstrous metamorphoses beyond even the imagination of their makers—the medium itself distorts, shatters, fragments and swells and colours up under its own energies, and these accidents of physics can then be selected as a natural part of the phantasmagoric spectacle.

Giorgio Vasari in the sixteenth century defined the grotesque as "a kind of licentious and highly absurd art" (*"una spezie di pittura licenziosa e ridicola molto"*).[3] The scariness and shock excited by grotesque images verges on hysterical hilarity, and this peculiar pleasure, poised on the edge of unbearable discomfort, undulates like a recurrent fever, a kind of malaria in the blood of culture, now delirious, now imperceptible and in remission. The grotesque can take the form of *capriccio*, as in the ludic inventions of Raphael and his *seguaci* in the Vatican, or it can find expression as *terribilità*, when it translates the monstrous into an aesthetic. When *terribilità* takes hold, as it has today, then the grotesque apes Dionysiac excess—hedonism taken to extremes—even while it expresses a grating irony about hedonism's naïve hopes of undiluted gratification and pleasure.

The grotesque and the monstrous are closely associated. But a distinction can be usefully made: one belongs in the order of representation, the other to the order of nature, so that, for example, King Kong, the giant ape and eighth wonder of the world, is a monster in the story, but the effect of his automated figure, his rampage, his rolling eyes, his flaring

nostrils as he examines Fay Wray in his huge palm, produces the frisson of disgust and pleasure combined, the quality children call scariness, but that can also be caught under the rubric of the grotesque. Similarly, Mike Kelley's handknitted soft toys are furry beasts, little monsters who act as points of identification for their owners, foils to their power to love and to withdraw love. Some of the soft toys are hybrids, invented creatures or winsomely anthropomorphised variations on familiar animals, but many transmute once feared wild creatures—bears, above all—into docile pets. In Mike Kelley's icons of them, or as props in his performances, these soiled and battered alter egos of the monstrous child-self become grotesques, akin to the comic horror of gargoyles who grin from medieval cathedrals. Confronted with this uncanny and shabby detritus, fascination and repulsion coexist.[4]

"The closeness of sublime to grotesque ... (is) not incidental but structural," comments Morton Paley in his book on the Apocalyptic Sublime.[5] One distinction that can be introduced is that the sublime needs an observer to experience its heights and its depths; the aesthetic depends, as Burke assumes, on spectacle and vision. Spectators of the Enlightenment delighted in the terrible beauty that occurs in nature, and their representations or reanimations of abnormalities fill the cabinets of anatomical museums in Florence, Bologna, and the Royal College of Surgeons in London. This last still exhibits, for example, The Irish Giant, who toured in travelling peepshows as The Tallest Man in the World, eight foot and two inches high.[6] Beside him in the same vitrine stands the skeleton of the Sicilian Fairy, Caroline Crachami, who was exhibited by an unscrupulous doctor in England. Her miniature thimble and her tiny slippers are arranged near her bones: she stood only 19.8 inches high when she died in 1824, aged nine.[7] In a laboratory jar, miscarried quintuplet foetuses, their flesh blanched by the chemicals in which they are preserved, are apparently ascending, their closed lids and open mouths making them appear to be singing, a quintet of ghostly choristers. This is

"the real in the extreme," as Thomas Mann called it: nature's prodigies of difference on display. Observable phenomena, collected, preserved and classified, used to put on enough of a show (monster does stem from *monstrare*, to show) to provoke wonder and disgust and awe, the defining responses to the sublime. Paul McCarthy's mannequins, like his little girl with a penis, evolve chimerae on the principles of such freakshows.

A decisive shift took place in the late eighteenth century: the monstrous that was found marvellous in nature during the Renaissance yields pride of place to the wonders of the imaginary realm — the demons flying from the brain of the sleeper in Goya's *Capricho*, "The Dream of Reason Produces Monsters" (itself alluding to this aspect of the grotes-que). The fantastic is displaced from the external world where it reflected the sublime and terrible multiplicity of creation, and comes to find a new, wholly unstable habitation in the mind of an individual; it becomes one with the subject or artist's consciousness. The eyes that behold the grotes-que today and then make it palpable are thus turned inward, and the won-ders are generated *ab nihilo*, with no referent in nature, but only in fantasy. Matthew Barney's modern satyrs, in his video piece *Envelopa: Drawing Restraint 7*, are assembled from the fancy-dress cupboard of monstrous mythologies, combined with prostheses that effectively cripple them.

Vision in this case does not gaze at awesome or disgusting objects outside of itself, but conjures spectres within; the double meaning of other words besides "vision," like "illumination," does not give much help here. The nightmares evoked by Goya and by artists of the Counter Enlightenment such as Henry Fuseli, conduct us into painful subjectivities, and if they make a claim at all at representing objective manifestations, it is a weak one, beset by a very contemporary anguish that their visions are all in the mind: delusions. Their successors number the frenzied phan-tasmagorists of contemporary art, who conjure fantasies from dummies, mannequins, still camerawork, video film: Kiki Smith, Sarah Lucas, and Paul McCarthy, as well as Matthew Barney, Cindy Sherman and Mike Kelley.

> Photography is the chosen medium of preference for so many late grotesque artefacts because it offers two contradictory capacities: on the one hand, its capacity to mortify — in the literal, prime sense of "making dead"— and on the other, its spurious, but intense claim to truth.

Late, or millennial grotesque contemplates monsters of its own creation, existing beyond the real, taking visible forms in every state of the unconscious or hyperconscious mind: reverie, fantasy, phantasm, hypnagogic hallucination, trance, vision, rapture, nightmare, amphetamine illusions, simple daydreams, plain night thoughts when sleeping. The monsters are no longer prodigious births, sports of nature, exotic marvels; they have taken up their habitation inside persons. Photography, with its special historic claim on the real, lends itself especially ripely to the convincing conjuration of these chimerae.

Contemporary twists on the grotesque do not any longer even always require that the objects of the representation be monstrous or even fantastic: the atmosphere of a work can be utterly grotesque, even when the forms it deploys are not disfigured, unnatural, outlandish or even curious. The thrust of horror today, in comics, films, and imagery pushes the ordinary into the realm of the uncanny, so that the light of the common day itself clouds and curdles. Cuddly comfort rags, children's toys, familiar bottles of condiments, and other homely and harmless objects turn foul and sinister.

Photography is the chosen medium of preference for so many late grotesque artefacts because it offers two contradictory capacities: on the one hand, its capacity to mortify — in the literal, prime sense of "making dead"— and on the other, its spurious, but intense claim to truth. Both these functions — mortification and realisation — relate to the concept

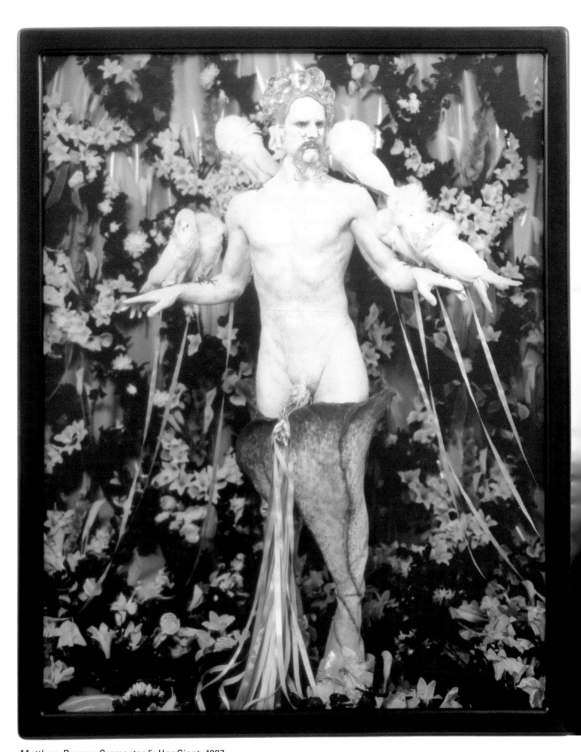

Matthew Barney, Cremaster 5: Her Giant, 1997

of the *vera icon*, the veil of Veronica, and the magical function of represen-
tations of the dead.

The medium's polar powers make the question of control crucial:
What will this magic achieve? Can the performance remain in charge of
its meanings? Can the image contain its content? The answer is hardly
yes, and artists no longer admit to seeking mastery on Michelangelesque
lines. Nevertheless, amid all the discussion of the abject, the power with
which the representation of impurity and danger invests its conjurors
tends to be neglected. The artists assert their authority over the "transi-
tional objects" they employ in their works, and they reach out and make
the viewer a participant, in the same way as a ritual cannot be observed,
because the congregation willy nilly becomes part of the ceremony. The
artists' play, playacting, and masquerade dominate; their fantasies get
under our skin. This disturbing power, which in different ways emanates
so strongly from Barney and Sherman and McCarthy's ceaseless experi-
ments with the grotesque, arises from the long and deep relationship to
magic that these forms of image-making possess. "Let's pretend" makes
an assault on truth: it lives chimerae as if they are real. Children's games
dissolve the border between what really happens and what is imagined
to happen, and so do the icons and films of contemporary artists, on pur-
pose, with far more wilfulness than children. It is also the case that
scatology and the obscene find a permitted, unremarkable niche in such
children's games of make-believe. I had a doll which came with a baby
bottle and when I fed her, she wet her nappy. The baby dolls called Beanies
are now so popular that toy shops have to restrict customers' purchases
to three each; they are depicted with runny noses, tears, and even
screwing up their faces as if they were dirtying their nappies or having
wind. Children punish their dolls, push in their eyes and fling them around,
maimed and without limbs. Such games with dolls are structurally analo-
gous to Cindy Sherman's playacting with dummies, and openly invoked by
Mike Kelley's staging of nursery games.

The path that Sherman has taken, from the cool black and white film still impersonations of the late 1970s to her present obsessive representational havoc seems to me emblematic of the grip that the grotesque has reasserted on the aesthetic imagination. Her *Monster Mask* screams apotropaically, a demon of glowing scarlet; her series of hacked sex dummies vandalise bodies in effigy in ever more grisly permutations of sexual violence.

The importance of the child as the origin and pattern of such play arises from a widespread cultural commitment to children's inherent antinomianism, interpreted as a kind omnipotence in self-gratification — Freud's polymorphous perversity. Fear as well as power animates the games they play, and not only with dolls and dummies. The "It" who comes to catch you in games of tag is a figure of death or the devil, of the bogey (the word means devil) that lurks in the dark and waits to spring out on you. Interestingly, Tony Oursler's babbling heads and stuffed, partly concealed dummies were inspired by the most common made-up bogeyman of all — the scarecrow.[8] This ancestor of imaginary monsters opens up one of the most crucial meanings of the grotesque: its use in apotropaic magic, in figures like the sheela-na-gig, who spreads her labia maiora to expose her vulva in a nether grimace, on gateways, towers, doors, in order to act as a guardian.

Images of the dead can act to rescind death's reach, in the same way as the vernicle itself, the miraculous image of Christ in his passion, became an amulet. Like all Christian relics, it was reproduced serially and infinitely, merely by contact with the original — an image of an image in Catholic theology is imbued with the virtue of the model, and thus anticipates the photograph. The profusion of bodies agonistes in contemporary art represents a struggle to seize on every imaginable horror and reproduce it, as if the very invocation of mayhem will act to hold it at bay. The more gory the martyrdom in Catholic cult, the more efficient the martyr as saint, as an intercessor on behalf of the living. The grotesque fantasies of

Kelley and Sherman significantly make a claim beyond subjectivity: they are not presented as personal (though they might well be) but as generic emanations of human fantasy and its apparent immeasurable compass, its sublime and grotesque abysses. That in itself, beyond the immediate spectacle of pity and pollution that artists offer, is an assertion of the magical authoritative properties of the image and of image-making.

[1] Horace, "On the Art of Poetry," in *Classical Literary Criticism, Aristotle, Horace, Longinus*, trans. Theodor Siegfried Dorsch, Harmondsworth 1965, p. 79. See also Ernst Gombrich, *The Sense of Order. A Study in the Psychology of Decorative Art*, London 1994, p. 255.

[2] Fransisco de Hollanda, *Four Dialogues on Painting*, trans. Audrey F. G. Bell, Oxford and London 1928, pp. 61–62.

[3] Giorgio Vasari, *Le vite de' più eccellenti pittori, scultori ed architetti italiani*, Florence 1550, quoted in André Chastel, *La Grottesque*, Paris 1988, p. 12.

[4] Mark Dorrian, "On the Monstrous and the Grotesque," unpublished paper, kindly lent by the author, who has provided many insights.

[5] Morton Paley, *The Apocalyptic Sublime*, New Haven and London 1986, p. 7.

[6] He was Charles Byrne (later O'Brien), born in Ireland in 1761, died 1783; his skeleton in fact measures just under 7 foot 8 inches. See Elizabeth Allen, *A Guide to the Hunterian Museum*, London 1993, p. 26.

[7] *ibid.*

[8] See "In the Green Room," Tony Oursler and Tracy Leipold in conversation with Louise Neri, in *Parkett*, no. 47, 1996, pp. 21–27 and Lynne Cooke, "Tony Oursler's Alters," *ibid.*, pp. 38–40.

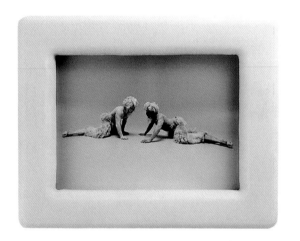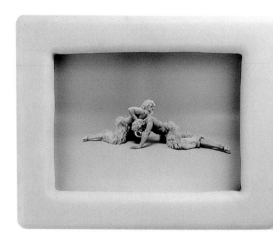

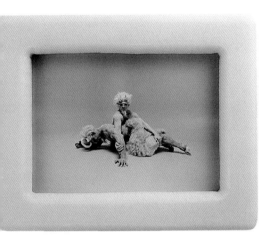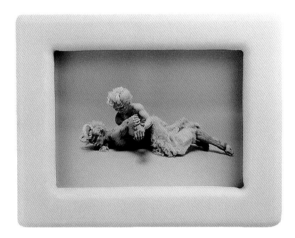

Matthew Barney, Envelopa: Drawing Restraint 7, 1993

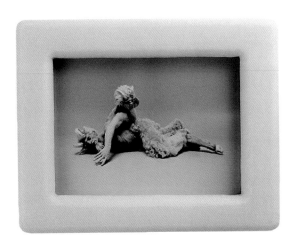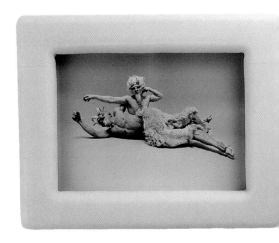

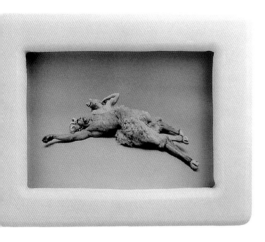

Paul McCarthy, Props/Objects: Daddies, 1995

Cindy Sherman, Untitled # 235, 1987–90

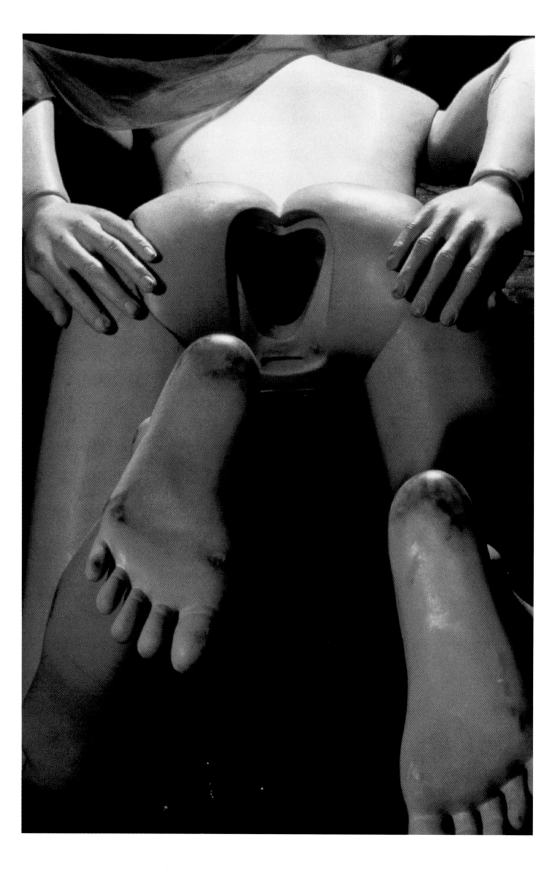

Gilbert & George, All, 1996

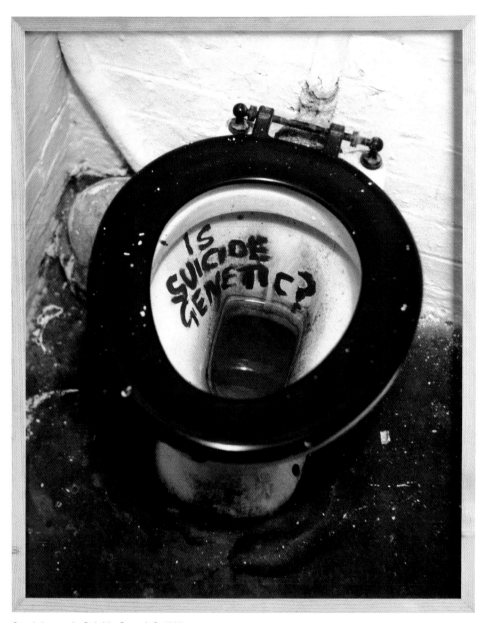

Sarah Lucas, Is Suicide Genetic?, 1996

Stuart Morgan

"Once Very Familiar"

"If you look at the photo of me as a kid with the head, my eyes look like I'm laughing but actually I'm terrified.... I'm thinking 'Quick! Quick! Get this shot over with.'"[1]

A teenage boy laughs as he kneels to be photographed with a man who could be his grandfather. As the shutter clicks, the aged relative seems to be enjoying the attention. He grins conspiratorially while whispering something out of the corner of his mouth, perhaps one of those family jokes that still makes everyone laugh despite the fact that it stopped being funny long ago. ("Watch the birdie!" yells the photographer, the long-suffering sitters giggling because there is no birdie to be seen and the phrase is so unfunny that it makes everyone laugh all the more.) But funny or not, in this case levity seems misplaced, for the boy is playing a tasteless joke: the older man is dead.

In an essay written in 1909 called "The Uncanny," Sigmund Freud defined the term as a particular sort of terror, one that is frightening because it leads the patient back to something that he or she already knew. So the word "uncanny" is an appropriate description of a series of six photographs made by Damien Hirst in 1991.[2] But why? One of the six images was a bowl containing liquid, but with a black square hiding an object floating inside. In another, the artist sat screaming in mock or real terror. Two more photographs followed and each time something in them was obscured, first by a row of empty hospital beds and secondly, by Hirst himself, musing as before on an object concealed by another black

square, perhaps a cipher for whatever will most disturb the viewer. But there is one difference. This time there is no doubt about the hidden object in question; it is a severed human head.

There are many ways of interpreting the photograph of Hirst with a "dead head." First published in the pilot issue of *Frieze* magazine, the offending head looked all the more harmless for being passed off as a postscript at the end of an interview, in this case to document Hirst's first exhibition in a private gallery.[3] In that first exhibition, he held butterflies captive in a sultry environment, allowing them to feed and to fly but not to be released. The results were interesting and the relationship between the butterflies and the viewers seemed strong, though this feeling might have been imagined: an excuse for the public to pretend some deep bond between human beings and the animal world.

In the 1988 exhibition, "Freeze," which was organised by Hirst and served as the launching ground for the careers of a number of young British artists, an interest in taboo subject matter dominated. For example, Mat Collishaw's contribution was a light-box titled *Freeze* (from which the exhibition borrowed its name) that consisted of a gridded, magnified photograph of a deep, bloody head wound. In the past, Collishaw had used other spectacular images, such as those of children with Down's syndrome, a series of female suicides, and a slide projection that showed a beautiful woman apparently bound to the rafters of a large, empty building in South London. Yet another example of his off-colour subjects was a large, two-dimensional, automated image of a zebra penetrating a nude woman, an image borrowed from a Victorian pornographic print.

Other examples of taboo subject matter are not difficult to find in recent British art. For example, the lack of irony in Sarah Lucas's blown-up versions of front pages from the gutter press have much in common with the work of Gilbert & George, whose images have included human faeces and male genitalia. Even more shocking are Lucas's attacks on sexism, such as *Two Fried Eggs and a Kebab* from 1992, which is based

on René Magritte's famous painting *Le viol* from 1934. In Magritte's painting one sees a woman's facial features replaced by those of her body — the breasts where the eyes should be and the pubic area as a mouth — representing female identity in grossly sexual terms. Violence, whether real or threatened, has also played a large part in Lucas's work, for example in the photograph of the artist sitting in a chair and staring confrontationally at the viewer with the sole of her heavy boot filling the picture's foreground; or, an even later work that showed razor blades sticking out of the boots' toecaps. In another of Lucas's photographs, one sees a close-up of the artist's face wearing a menacing expression and munching on a banana: an image that insinuates phallic violence.

It could be argued that the most influential artists behind this aggressive examination of everyday life in British art have been Gilbert & George. At the outset, their pose as upper-class gentlemen seemed patently satirical, another example of traditional English "silly ass" humour. Gradually, however, a more subtle plan emerged. Their early furniture pieces and drawings seemed both sinister and romantic: a celebration of their relationship while remaining aware of its constant vulnerability. But as their life together continued, other factors emerged: the darkness of bare boards, the danger of alcoholism, the temptation of beautiful young boys. Meanwhile, as their photographs became monumental in scale, they continued to use themselves — their own bodies — in their work and to reflect, more and more, on the area of London where they live. Brick Lane boasts a strong Pakistani community, while also housing rich people like Gilbert & George, and the combination of these factors in their art is as potentially inflammatory as the real situation itself.

All this could be viewed as part of an ongoing attempt to wean British art from that blend of illustration and sheer niceness into which it has always been in danger of falling. Such developments might be construed as out right attacks on British behaviour in general, particularly the myth of British "good manners." It is true that even as early as the "Freeze"

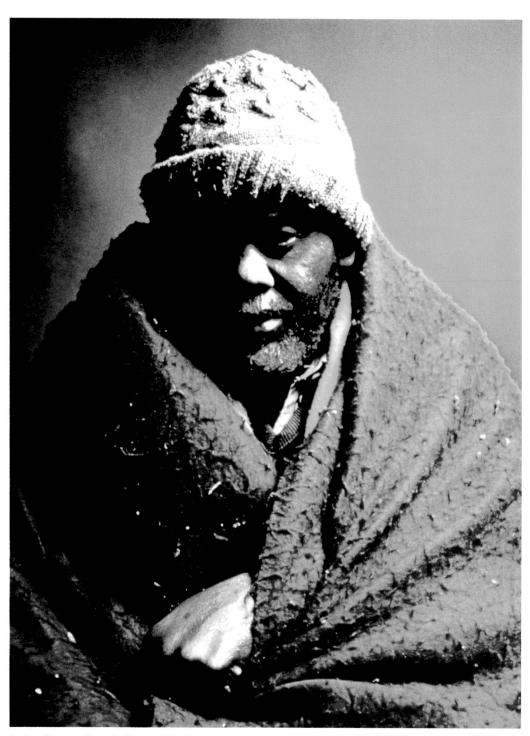

Andres Serrano, Nomads (Roosevelt), 1990

One way for Damien Hirst to parody the politeness
of Conceptual and Minimalist art was to deal with flesh
and blood.

exhibition, comments were being made about this national dedication to
politeness. In time this new trend would usher in a confessional strain,
as in the art of Tracey Emin, a Dickensian waif in whose thinking pathos
and embarrassment play a large role. Or, Gary Hume's *Door Series*, in which
the glossy surface of his large paintings first attract the viewer, then re-
buff him or her with their glaring sheen. While these paintings may be inter-
preted as a comment on the English as superficial, devoted to half-truths
and little else, another reading suggests that they might be images of
closure, to be interpreted not merely as the result of snobbery but also as
the apparent impossibility of ever getting somewhere in the world out-
side of Goldsmiths College. (After all, the artists in "Freeze" had only just
graduated.)

One way for Damien Hirst to parody the politeness of Conceptual
and Minimalist art was to deal with flesh and blood. By this time, exhibi-
tion design had turned into a set of variations on the theme of the "white
cube." His answer to this was to construct in his exhibitions a living — or
a dying — area. In one instance, Hirst presented houses for butterflies on
the basement floor of a gallery in Woodstock Street; designs that were
scaled down, of course, to butterfly proportions. (The rooms that he was
to make in the future, with titles like *The Acquired Inability to Escape*, may
have been related to these office-like elements.)

Hirst produced these butterfly pieces in series and they were in-
spired by a figure from his student days, a certain Mr. Barnes. From his
window, Hirst noticed his old neighbour going out every morning and re-

turning with plastic bags full of objects that he had picked up during the day. One day, however, Barnes disappeared. When Hirst realised that his neighbour was gone for good, he and his college friends broke into the house and were amazed by what they saw: "Rooms packed from floor to ceiling with objects he had amassed, at some points leaving only narrow pathways through which to move…"[4]

As a direct result of this experience, Hirst became a *collagiste*, using Mr. Barnes's finished, or half-finished, work as his starting point. The importance of each object's age and the fact that they were handmade was accentuated by Hirst in a style that was often rugged and pretty at the same time. Another legacy from Mr. Barnes was the idea that a work of art might also serve as a dwelling. But it was the extremes found in Barnes's house, its prison-like quality on the one hand and its handmade, even cosy look on the other, that probably had the most impact on Hirst and his work; it was a contrast that influenced not only his butterfly pieces but also the sculptural hybrids of furniture and museum display cases.

Much has been written about the role of the vitrine in contemporary art and Hirst exacerbated the discussion by dramatising an object's status by putting it behind glass, equating the display case with a cage. The caged aspect was evocative of boredom and the boredom of everyday life was such a frequent theme in his work that Hirst even invented a term for it: an "acquired inability to escape" which he offset by another tendency, that of the promise to love someone "until I don't." Might such a hard-boiled approach explain the depth of Hirst's respect for Barnes, a man who may not have died at all but simply made the decision to move on?

As his career has continued, Hirst's approach to boredom and to life and death, became a major point of discussion. For example, his use of raw meat in a 1996 exhibition at the Gagosian Gallery in New York caused a sensation, though the reasons behind the outcry sometimes remained obscure. (Predictably, vegetarians protested.) At the root of the arguments

about Hirst, however, lay an uneasiness with the simple truth that firstly, we are essentially flesh and blood, and secondly, a recognition of our culture's almost biblical approach to dead bodies.

In the end, the most poignant message in Hirst's art may be the one that is often overlooked: that of the alliance between mankind and the animal world. In a way, we are just like animals, kept in a form of captivity for most of our lives, pacing around our cages and looking for a way out. Boredom and desperation loom large in our lives, a point that Hirst exaggerates. And he does this not only by placing butterflies or houseflies in glass containers, but also ordinary objects like a desk or an office chair. He also fills glass cabinets with unopened drugs straight from the chemist, like the pain-killers in a 1994 work whose title, *Looking Forward to a Complete Suppression of Pain,* conveys a powerful death wish.

The importance that repetition and its relation to boredom play in Hirst's thinking is suggested by the title of his book, *I Want To Spend the Rest of My Life Everywhere, With Everyone, One to One, Always, For Ever, Now,* which is probably Hirst's own definition of heaven. But the definition of pure pleasure might also be seen in the singular monotony of his "spot" paintings, which resemble nothing more than colour samples. This use of spots in his art is allied to his cabinets of medicinal drugs, if only in the passivity of their display, like items for sale in a shop window. This idea of passivity, which is probably borrowed from Joseph Beuys, whose interest in chemistry was well known, infers that art is healing — a view that Hirst would support. So is the love of darkness and the grotes-que in Hirst's work balanced by sheer playfulness? Not quite. As he has explored the physical reality of death both in his installations and his photographs, as well as the mechanisation of the meat and arms industries, the chances are that this more dark and serious side is already turning his thoughts to the metaphysical.

[1] "With Dead Head, 1991," in Damien Hirst, *I Want to Spend The Rest of My Life Everywhere, With Everyone, One to One, Always, for Ever, Now*, London 1997, pp. 98–99.

[2] *The Uncanny*, exhibition catalogue, Gemeentemuseum Arnhem, The Netherlands, 1993, p.37.

[3] Andrew Renton and Liam Gillick, *Technique Anglaise*, London 1991, n.p.

[4] Stuart Morgan, "Damien Hirst," in *Frieze*, no. 1, summer 1991, pp. 23–25.

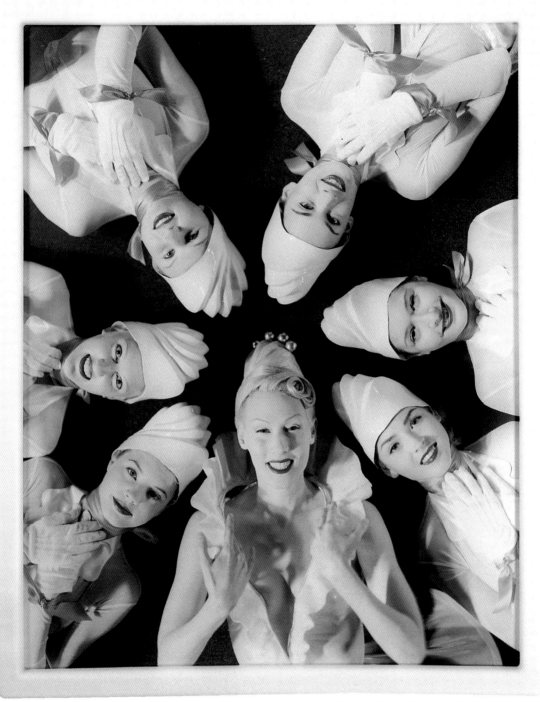

Matthew Barney, Cremaster 1: Orchidella, 1995

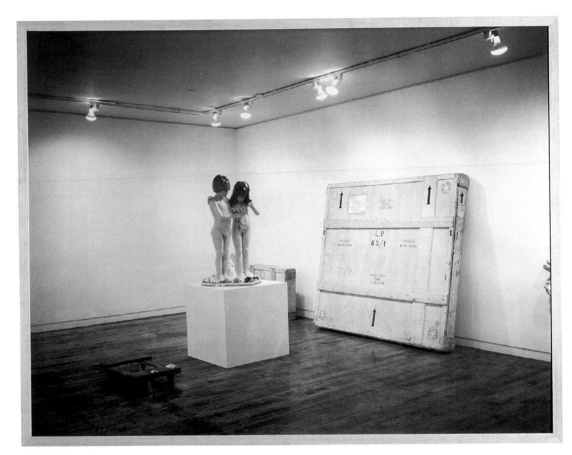

Louise Lawler, Dolly, 1989

Allan McCollum, Perpetual Photo # 217B, 1989

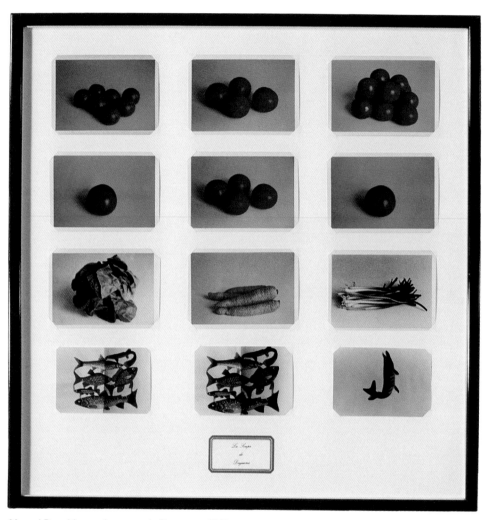

Marcel Broodthaers, La soupe de Daguerre, 1975

Louise Lawler, Salon Hodler, 1992

Louise Lawler, Portrait (Parrot), 1982

Jeff Rian

Washed Up on
the Shores of Light

Blaise Pascal trembled in awe just thinking about the silence of the cosmos. His thoughts were among the West's first real inklings of Nothingness — our existence a fluke of necessity in a godless void. He recommended hedging all bets, to receive the sacraments and dowse frequently with holy water. You never know, he thought. Ever since, scientists and writers of fantasy literature have endeavored to tame the void by uncovering its source, the idea being that the more we know about the "it" the more "it" will be ours. Thus, knowledge became our Valhalla, scientists its guardians, and journalists the apostles of truth.

Two centuries after Pascal the French poet Alphonse-Marie-Louis de Prat de Lamartine claimed that the speedy newspaper had usurped the power of the book. Within a century, technology and photography would accelerate life and representation, archeology and anthropology would flourish, and psychologists would endeavor to quell our alienation. In the late 1920s, the eminent literatus, Edmund Wilson, claimed that the internal combustion engine had changed our sensory life — so quickly had it transformed life's hithers and yons. Then came television and its accessories — fast food, tract housing, leisurewear, recliners, bad posture, two-liter Diet Coke, pizza and egg-foo-yung at your door, and Prozac. Not since Plato's grumbling that writing had destroyed memory (*Phaedrus*, 275) had a technology so epic, so fast, and with such seeming innocence, transformed our knowledge or extended so far the news

beats of the apostles of truth. Information was never more rife, or certainty less certain.

Evidence suggests that we are never quite prepared for the things we invent nor so cognizant of their after-effects. This queasy uncertainty, however, is evident in art; those messages-in-bottles where such recognitions as Pascal's, Lamartine's, and Wilson's are synthesized metaphorically and set adrift. Yet artists' messages are rarely as clear as one would like. This is partly because art arises from intuitions that aren't always so clear to the artists themselves. Otherwise why make art?

Artists are like researchers and systems analysts interested in life's less explicable gestalts: questions about existence, the "whys" of authority, the fragility of identity, the syzygy of beings and things. Using varieties of matter, they probe the world of things and ideas and cobble together representations which, at their best, include a bit of originality and style. Through them we receive messages that resemble or validate or enhance our own intuitions. When communicated effectively, artists' intuitions relieve us of our alienation by reminding us of our uniqueness in the void. Sometimes their messages recall our very inventiveness.

Take, for example, a newspaper and a Cubist painting. Newspapers are flat surfaces, classically structured in columns, with headers and subheads, and like a Cubist still-life, they offer simultaneous perspectives. But where newspapers traffic in global details, the cubists of 1912 were more interested in form than substance (Cubists offered a paucity of subjects).

Newspapers bring information from the margins of the world to its capital centers. At the home news room the journalists' reports, a few pictures (to further impress our trust in their facts), and some ads (to keep them afloat) are pieced together into the paper's formal gestalt. Cubists, on the other hand, intuitively drew inspiration from the speed of modern life, Einstein's relativity, the visual and psychological intensity of film's montage, a newspaper's mosaic of time and space, the ungainly sputter of a motor-

Artists are like researchers and systems analysts interested in life's less explicable gestalts: questions about existence, the "whys" of authority, the fragility of identity, the syzygy of beings and things.

car. Neither news people nor Cubists might have recognized their similar fracturing of a planar surface. However, they were aware of a shared interest in the West's dominating, if mythic, idea of progress and about the power of invention, of which paintings and newspapers were cultural highlights.

Today an artist like Barbara Kruger rubs our noses in the paradox of mediums and messages. For how many of us consider the suggestive relationship between those lingerie ads in the first section of the *New York Times* and the conflicts of power and reason that we glean from its texts? Picasso may have pasted a newspaper clipping onto a still life, but he wasn't necessarily any more aware of its implications than the paste-up artist at *Le Figaro* was about his employers' control of its content. But Kruger's slogan, "I shop therefore I am," also conceals a "buy me" come on. Isn't that a paradox, too?

A newspaper's layout, advertisements, news and sports sections are the same in Beijing and Little Rock, as are newscasts in Timbuctoo and Minsk. Art and art galleries look alike across the world, too. Nowadays artists draw on the formal gestalts of fast media of which film ranks as its cathedral and television no more as a "high" art than a newspaper was to Picasso's generation. And yet its reach and portability have influenced a sameness across the globe.

Big media like film and television are too expensive for most artists. Instead, they address it using the cheaper one of photography — as

well as video. Many would like to branch out in a bigger way. But photography is not just cheaper, it also contains the seed from which all those speedy and expensive media evolved. This is important. For in their response to the mass-media's torrent of one-way transmissions, artists are not only trying to advance art but also to preserve it. And even though somewhere deep in every one of them is an urge to construct a Chartres in film, big media don't always allow them to be auteurs. But looking back to David's undoing of Goliath, we should remember that a small medium like photography can be very effective.

In the past, the Word was the be all and end all of knowledge. Today, images are integral to our thinking, and television has so inhabited us that its effects are boundless in every sense of boundlessness, refocusing the whos, whats, whens, wheres, and hows of public communication, even altering the learning process by offering experiences that one does not have to participate in — and all the while giving us seeming control. The world is brought into the home at the push of a button. This form of experience is no less real or engaging than any other, except for the fact that it is a different kind of sensory experience than eating, playing games, or making love. Some say that to prohibit a child from watching television is like giving them life without fire. Others call it the source of our discontent — which it is not.

Television sped up the newspaper's mosaic style. Messages are disseminated in a discontinuity of jump-cuts of twenty seconds or less; its images, owing to the limitations of light-through transmission, are slightly diffused around the edges, making them soft. Being a close-up medium, its advantage over books is to return face and body gesture to one-way communications — which is impossible in print and reduced to a frame in photography.

According to AC Nielsen Media Research, the company whose surveys are responsible for the life and death of virtually every American TV show and whose ratings are the bible of every advertiser — the latter

being the sponsors of television programming—an average American household spends about seven hours per day in front of a television. Before its existence, over sixty percent of America was asleep by midnight.[1]

In TV's first decade, at least in America, democratic-capitalism's utopia was represented in magazines like *Reader's Digest, Life, Look, Better Homes and Gardens* and in the Sears and Montgomery-Ward shopping catalogs. These were perfect worlds, balanced ecologies unto themselves, crafted and designed to represent our sensory and social attitudes and our power to shop. Television proliferated from these models. "Progress is our most important product," repeated Ronald Reagan, the host of *General Electric Theater.*

The most prolific postwar population group were teenagers.[2] They were at once heavy consumers and the work force in the service economy that was evolving. The mass media exploited them financially while titillating their imaginations. But those who grew up on TV also resisted the worn-out ideas of life before television. In fact, they had learned something about life, representation, self-consciousness, and even intimacy that went far beyond expressionism, a talk show interview, or a lonely heart's confession. They were learning life through images and having out-of-body experiences that reflected a different reality from the one taught by parents and at school. Parents were unprepared for this and never failed to remind us.

Confusions were occurring between life as seen in the media and as it was experienced in school and at the dinner table. There were no rules of grammar or syntax for electronic media. They attracted our desires and focused our obsessions, but did not necessarily promote understanding. However, the artists and hippie mystics of the new age, being by nature obstinate but curious, let the world know that things were different.

TV had engendered a form of expression which, for the artistically inclined, made an abstract expressionist like Barnett Newman's grappling

with the cosmic void look quaint. Transmogrified bodies and talking heads were proliferating faster and faster. A light-emitting living-room appliance had projected onto viewers every variety of expression and shtick. Life was being resynthesized and reformulated, and the photography-based art that evolved reflected the mentality it fostered, just as Cubism once represented fashionable café society. Budding TV-bred artists responded as much to Newman's artistic lifestyle as his art. Their art projected life "seen" as life "felt" and borrowed the "look" of mass communications to create their style.

Culture is the result of selection and classification. Its tools for achieving this end are its media, whether speech, script, or electronic transmission. Television extends our senses across time and space. Its images and characters are selected by professional market surveyors and tailored to fit the patterns of our impressions. Its icons are real people who are symbolically prolific. Unlike a traditional icon, which stands for its object through a resemblance, icons of real people focus our desires for perfection and inclusion. They are designed that way. But their effect is to make us feel self-conscious.

By the 1980s, the art world's two most salient historical referen-ces were Marcel Duchamp and Andy Warhol. Duchamp was the avatar of the artist-as-intellectual, in which art was an exercise in contemplation and creative gesture. A proto-game theorist, Duchamp recognized that a variety of strategies were necessary for an artist's survival. One of his was to use found objects (readymades) to elicit meaning. He suggested that mass-production was encroaching on the handmade but that its ob-jects had become as fecund an instrument of expression in our time as a Madonna was in the past—so long as the object was appropriately re-contextualized.

Warhol was the avatar of media-based art. He fed images through a traditional art form—painting—using an assembly-line-styled photosilkscreen process. He exemplified the successful transition of the

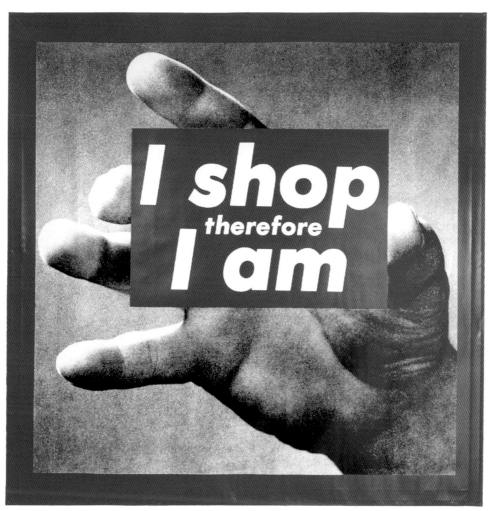

Barbara Kruger, Untitled, 1987

Andy Warhol, Hammer and Sickle, 1975–76

everyday to the transcendental. Repetition and reproduction were attributes of his style. His subjects were larger than life, his colors had the glitter of a cartoon, and every image he used was as familiar to us as a still life or bust was to the café glitterati struggling to understand Cubism.

Anyone whose formative years includes large doses of television is habituated to disembodied voices, jump cuts, collage, pattern recognition, and a discursive (if dyslexic) form of logic. Most young people's viewing habits are to some extent parentally controlled — which was never the case with a newspaper. Despite any attempts to thwart them, they learned patterns that focus everywheres and everywhens in cubisms of simultaneity. Images became second nature. Photographs came to constitute an artist's palette, and many began to collage or simply re-present them. They learned to "scavenge" (as it was called early on) images and styles and to reuse them in a manner that reflected life as witnessed. Few had studied photography or any other technique in depth, yet the "look" of gallery art and of commercial reproductions inhered to their works. Technique had become a pastime, a hobby. However, having been raised in a system that rewards specialists, they often focused on a particular subject or style, and, as they had learned from Duchamp, specialists were engaged to assist them.

Artists learned to use objects and images like Tarot cards to elicit memories and to capture an artistic "aura," to borrow from Walter Benjamin, a key figure in the theoretical "discourse" that evolved.[3] Photographic images were used to create a mnemonic effect, to release a familiar response which could be interpreted according to any "theory" or theoretical methodology one chose to see it from. Meaning had become as variable as our perspectives. Artworks were being read for their social and political content. Artmaking itself had become a metamessage in a world of signs — signs that signal our passions but do not symbolize a belief in anything greater than technology itself. One of art's messages in the bottle was to look again at our habituated imagery, which is what

they were doing when they scavenged and recontextualized all those reproductions. Artists had become anthropologists of the present.

Richard Prince photographed magazine images and advertisements in close-up, cropping the captions, creating soft, grainy "rephotographs," as they were called. Cindy Sherman made film stills of herself portraying fictive personalities. Both artists pictured life as eye-witnessed. Louise Lawler photographed art in various interiors with the objective precision of an anthropologist, revealing the pervading international style and art as a trader's commodity. Larry Clark and Mike Kelley recalled, respectively, adolescent vice and their estrangement. James Welling's subjects were classical television images: Jell-O, tinfoil, curtain backdrops, old trains. Scale also increased to compete with museum-scale works, and with Cibachrome, artists like Jeff Wall and Thomas Ruff added the light-through look of a high-definition television.

Modern invention taught artists to probe the environment. A younger generation of photographers, such as Wolfgang Tillmans and Jack Pierson, have shied away from the clinical look of the "white cube" and a specialist's narrow focus and try to capture the "aura" of home movies and snapshots and engage their generation's collective mentality. Their images are often intimate and seemingly disposable — and more suitable to a scrapbook or 'zine than a museum. Their subjects are people their own age, friends, trends (both are fashion photographers as well), and alternative lifestyles, but they capture our life in green-glass — a world in close-up, fraught with self-scrutiny and self-witnessing.

Television informs these habits but it is not necessarily a direct source. It doesn't have to be. So ubiquitous a medium of expression is implicated by default—which is no surprise, considering that televiewing occupies about a third of a couch potato's life. For all its intimacy, TV has fractured the world's centers and margins (perhaps the many homeless reflect the fracturing of Home). Artists' missives are no longer to some ethereal beyond, but abstractions about identity and the religion of techno-

logy. Lying within, however, is an atavistic quest for grace. Today's void is a lot noisier than the one that so humbled Pascal. Wagers are in on technology replacing incarnation. Artists remind us to think twice before going all in. And we should, if only to remember.

[1] Louis Phillips & Burnham Holmes, *The TV Almanac*, Macmillan 1994. What will happen if or when these figures reach global proportions? Writing never had such an effect. Global time and toil have been indelibly altered by satellites, computers, and TV. Shipping and commercial trading are twenty-four hour operations. Even warfare is conducted at night.

[2] It wasn't until Edmund Wilson's era, the era of gin and jazz that the word *teenager* was first used, not entering everyday speech until the 1940s. And the word *adolescence* was first utilized in the Renaissance, during the time when school curricula were evolving; it described the period between childhood and maturity. In Pascal's time only the elite were educated, and for most, childhood lasted till around seven when they entered adult society as a smaller version, and were treated as such. See Philippe Ariès, *Centuries of Childhood*, translated from the French by Robert Baldick, London 1996, first published in 1962, a study on the relatively modern creation of childhood.

[3] In his essay "Art in the Age of Mechanical Reproduction," which became source matter in the 1980s, Benjamin suggested that reproductions were instrumental to art, but potentially destructive to originality and its "aura."

Charles Ray, No, 1992

Nobuyoshi Araki, Tokyo Cube, 1994

Andy Warhol, Uncle Sam, 1980–81

Richard Flood

Voodoo Auteurism:
Film Stills
and Photography

Larry Johnson's suite of six photographs, *Untitled (Movie Stars on Clouds)*, 1983, imagines identical, sweetly elegiac credit sequences for two of Hollywood's most fatally iconic films, *Rebel Without a Cause* (1955) and *The Misfits* (1961). On fluffy white clouds adrift over Technicolor blue skies, Johnson simply imposes the names of the stars in each of the films: James Dean, Sal Mineo, and Natalie Wood signify *Rebel Without a Cause*, and Montgomery Clift, Clark Gable, and Marilyn Monroe signify *The Misfits*. The series is arguably the most effective *double entendre* about the promise and the lie of cinematic immortality in contemporary art. (Only Andy Warhol's *faux*-innocent silk-screens of movie stars occupy similar territory.) Dean died in a car crash, Mineo was stabbed to death, and Wood died by drowning; all violently fatal baptisms into legend. As for Gable and Monroe, *The Misfits* was their last film; Clift lingered on with increasingly apparent disabilities for three more.

While the cast of *Rebel* remains pretty much frozen in amber and emblematic of glittering youth, the stars of *The Misfits* are more like touchstones for the cruelty of illusion: all three had stayed much too long at the fair and the film shows each of them in an almost documentary state of naked disintegration. In Johnson's photographs, it is assumed that we know the names and, more importantly, can supply the faces as well as an

emotional tenor, to those names. He further assumes that we carry within us those signifying freeze frames that confirm the emotional weight of who these people were; that we invest in the myth of artifice that is the cinema's greatest allure.

I don't remember exactly when I picked up Parker Tyler's book *Classics of the Foreign Film*. I do know that it was a used copy and that my purchase was well past the 1962 publication date. What I am certain of, is that it was my first book of film stills and that afterwards I never looked at a photograph in quite the same way. Prior to *Classics of the Foreign Film*, photographs were either things that were passed from hand to hand, eliciting cooing and clucking sounds in response to the frozen poses of family members and friends, or they were the most interesting parts of magazines. If the photograph was compelling, maybe the copy that it accompanied would be as well. Either way, photographs were essentially visual corollaries to facts and I tended to shuffle through them with less attention than I would pay to a spidery crack in the ceiling. Parker Tyler changed all that.

Classics of the Foreign Film was Tyler's attempt to widen the American public's nascent interest in, primarily, European film. The seventy-odd films to which the book is devoted are the selection of an aesthete rather than a critic, an enthusiast rather than a formalist. When I came into possession of it, I had seen none of the films under discussion and, even today, many continue to elude me. They range from the obvious, such as Robert Wiene's *The Cabinet of Dr. Caligari*, to the obscure, like Curzio Malaparte's *Il Cristo proibito*, to the debatable, as in Gustav Machaty's *Ecstasy*, up to the sublime, Satyajit Ray's *The Apu Trilogy (Pather Panchali, Aparjito* and *Apur Sansar)*. The text is wonderfully idiosyncratic but, for me at the time, more or less irrelevant. The stills were everything and Tyler's copious captions seem to acknowledge and reinforce that hierarchy. That the stills happen to look exactly like photographs also occurs to Tyler who, in a number of the captions, goes out

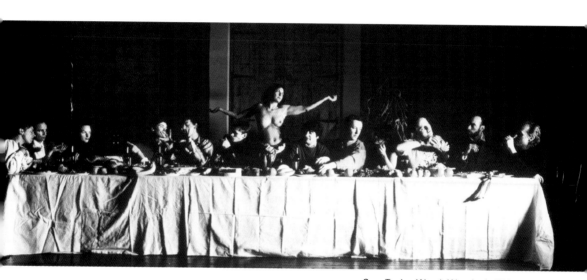

Sam Taylor-Wood, Wrecked, 1996

Craigie Horsfield, Plaça de toros La Monumental, Barcelona, 1996

The film still is an element of a completed act whereas the photograph brings with it no such assurance.

of his way to discourage such a misreading. For example, in referring to Alf Sjöberg's *Miss Julie* he writes, "Stills can be only modestly indicative of the superb flair for beautiful and picturesque action which carries along a hectic *liaison…*" And, about a still of Michelangelo Antonioni's *La notte*, he says, "Reunion between novelist and wife (at dawn on the industrialist's estate) does not come as easily as the above glimpse of the final scene makes it appear." Say what the author will, the stills stand independently from their cinematic context and that is what makes them so incalculably seductive and instructive.

The stills reproduced in *Classics of the Foreign Film* offer an encyclopedia of photographic practice and, looking at the book again today, I am naively amazed at just how imitative cinematographers appear to be of that practice. It is unlikely that by now there isn't a single photograph of note that hasn't been edited into the ever unreeling history of cinema and, I might add, fed back into the galaxies of images which reside in the overpopulated minds of those travelers — us — through the 20th century's *fin de siècle.* There is no shame in recycling per se; photography itself is a mechanistic parasite on the host of the real. Nonetheless, the film still is a glamorous fiction while the photographic set-up is a constructed lie. The film still is an element of a completed act whereas the photograph brings with it no such assurance. With the film still, you are free to move the scenario forward with no onus of personal intent; you are simply massaging a fiction. The extension of a photograph's narrative is psychologically more politicized. One's involvement with the extended narrative of a photograph introduces the potential for a kind of voodoo auteurism. A movie is always in the can whereas life is endlessly mutable and idle intervention has been known to kill.

Looking again through Parker Tyler's book, I started to imagine which director's stills would make the best two-dimensional exhibition. It was easy: Carl Dreyer *(The Passion of Joan of Arc, Day of Wrath)*, Alexander Dovzhenko *(Earth)*, Sergei Eisenstein *(Potemkin, Que Viva Mexico!, Alexander Nevsky, Ivan the Terrible,* parts I and II), Michelangelo Antonioni *(L'avventura, La notte)*. Such an exercise is ridiculous, as these directors are represented by the best stills in a book that excludes any images from pre-1961 films by Jean-Luc Godard *(A bout de souffle)*, François Truffaut *(Les quatre cent coups, Tirez sur le pianiste, Jules et Jim)*, Pier Paolo Pasolini *(Accatone)*, Agnès Varda *(La pointe courte, Cléo de 5 à 7)*, and Luchino Visconti (most notably *La terra trema, Senso, Rocco e i suoi fratelli)*, among many others. Regardless of the omissions, my "classic" film stills in Tyler's book were, by 1961, the gateway to radically new ideas about the narrative potential of photography. The proliferation of books on film that emerged in the 1960s gave anyone who was interested the sense that he or she could diagram the emotive magic of film through a designer's layout of stills on the printed page. Ingmar Bergman, Marguerite Duras, John Ford, Alfred Hitchcock, Stanley Kubrick, Akira Kurosawa—all of them offered lessons in lighting, composition and stylistic verisimilitude. In fact, all became accidental teachers of photography.

The influence of film on the visual arts has, in the last twenty-five years, been enormous. One need only think of a director like Alfred Hitchcock (represented in Tyler's book by *The 39 Steps)*, who has provided content for such wildly diverse artists as Victor Burgin, Stan Douglas, and Douglas Gordon, to understand the thrust and parry between the relatively hermetic world of art and the box-office driven world of cinema. Obviously, movies rule but postmodern art, with its incessant need to analyze and critique popular culture, is the ideal corollary to the movies and benefits enormously from its audience's pre-cued knowledge of the same. Artists like John Baldessari literally have constructed photographic collages from extant film stills. Others, like Victor Burgin in his Hitchcock-

inspired analyses of *Vertigo* and *Marnie,* shoot their own hybrid stills. The most obvious example of the film still-to-photograph-and-back-again is in the work of Cindy Sherman, whose mining of B-movie clichés yielded an extraordinarily complex critique of genre films. In a more conceptual practice, Richard Prince re-photographed existing pictorial advertisements without their copy and enlarged the potential discussion as to film's influence on advertising images. Prince's series of men's hands with cigarettes look less like advertising vignettes than like stills from Godard's *A bout de souffle* and his *Motorcycle Girls* illustrate the co-dependency of Roger Corman's biker movies and the motorcycle magazines that inspired him. Younger artists like Matthew Barney and Sam Taylor-Wood continue the relationship between film and photography. Barney has discussed the influence on his work of horror films and their directors, like David Cronenberg and Sam Rami. The editions of "stills" that supplement Barney's films and videos are spectacular indications of how to semaphore "cult" iconography. Sam Taylor-Wood's interests are more aligned with mainstream cinema, particularly the films of Martin Scorsese, but she brings to her photographs a kind of saturated *mise-en-scène* and narrative complexity that references in equal parts to Visconti and to Robert Altman.

To a certain degree, all of these artists can also be counted as the inheritors of Andy Warhol, who was the self-identified love-child of the coupling of art and cinema. His intuition about icons and the defining moment of iconicity was peerless and his ability to generate (and market) his very own movie stills remains unmatched among visual artists attempting to make the crossover into film. Like Parker Tyler, Warhol was intuitive rather than analytic and, just as importantly (perhaps more so), he was a fan. He treasured the defining moments and, rather than wanting to debunk or analyze them, he elected to celebrate the established pantheon. When it came to film, Warhol's genius lay in his complicity and the sheer wonder at its ability to create indelible legends. Rather than complain or dissect, Warhol flat-footedly celebrated the marvelousness of it all.

Cindy Sherman, Untitled Film Still # 49, 1978

Jeanne Dunning, Untitled Body, 1990

Holger Liebs

Who Are You, Spectre?[1]
The Mythical Potential
of Technological Media

"... the first impression, faint and tenuous in my memory, desired,
pursued, then forgotten, then recaptured, of a face which I have
many times since projected upon the cloud of the past in order
to be able to say to myself, of a girl who was actually in my room:
'It is she!'"

> Marcel Proust, *In Search of Lost Time, vol. II, Within A*
> *Budding Grove,* trans. Scott Moncrieff and Terence Kilmartin,
> London 1996, p. 473

"What you seek is nowhere; turn away, and you will loose your
beloved. / What you are looking at is a shadow, a reflected image."
> Ovid, *Metamorphoses* 1–4, trans. D. E. Hill, Warminster 1985, p. 111

Part of the mythical burden that photography has been unable to
discard since its invention is the motif of the *doppelgänger.*[2] Even early por-
trait photographs emanated a sense of split consciousness. The portrayed
subject encounters his- or herself in a frozen pose like a preserved speci-
men or ghost. It is a magical process, an obstructed narcissism — because
some (however minimal) degree of historical distance always delays the
requital of self-love. It is as if a fleeting mirror image had suddenly become

immortalised. But it also verges on an act of extinction, since the portrayed person — as depicted at the moment the shot is taken — will always be absent when the photographed image is produced.[3] Marilyn Monroe was said to have been *photographed to death:* it is precisely the realism of portrait photography that sparks the potential for myth and the fantastic. Whenever the technological medium generates images, like phantom pictures, of my own person, it unleashes psychic processes which function like hallucinations. Each portrait photograph is also an experiment performed on a living person, for it is a test of our memory, capable even of entirely suppressing it. Hence Marcel Proust requested that all his acquaintances give him photographs of themselves so that he would remember them.

The *doppelgänger* myth originated as a figment of romantic literary fantasies. However, modern media such as photography and film no longer have any need for the realms of the literary imagination. All cinema now requires is the darkened projection room of a movie theatre. The cinematographer substitutes the function of literary fiction with his frame sequences. Celluloid ghosts make tangibly real appearances on the screen. Even fear becomes reality when it is experienced with one's own body. *Doppelgänger* occur repeatedly, for instance, in early German silent pictures — as "metaphors for the screen and the aesthetic parameters of its appeal."[4] Take, for example, *Der Student von Prag* by Hanns-Heinz Ewers (1914)[5]: the film's protagonist is seen practising his fencing in front of a mirror when his reflection suddenly steps out of the mirror's frame to become — in the film — his adversary in flesh and blood. The "spectre" of the *doppelgänger* image always consists of the eerie presence of my own self in a picture generated by machines. This experience is menacing because it questions my identity. As Barthes sums up the mythical potential of photography, when confronted with one's own photographic portrait, "I am neither subject nor object but a subject who feels he is becoming an object. I then experience a microversion of death (of parenthesis): I am truly becoming a spectre."[6] The threat of extinction can be countered

> From the outset photography is inscribed with a sense
> of irrevocable loss, melancholy and mourning.

either by fully assuming the role offered by the image, or by keeping a distance from the "holes", the "gaps in time" (Rilke, *Sonette an Orpheus*). The first option is on a par with an enduring loss of identity, the second is tantamount to its reinvention.[7]

From the outset photography is inscribed with a sense of irrevocable loss, melancholy and mourning. How else is one to explain the relentless obsession of contemporary photographers for dramatisations of beauty, youth and eroticism? Photography might obfuscate my identity and confidently supplant the subjective images of my memory — but at least it always guarantees a fragile duplicate. It remains, while I grow old. In recent years numerous artists working with photography have addressed the themes of beauty, adolescence and the inexhaustible abundance of youthful sexuality. It is hardly a coincidence that many of them have chosen a sequential or cinematographically narrative approach in their work. In most cases, the issues examined relate to the formation or dissolution of identity, private group mythologies, sexual reproduction, death or youthful idolatry. Comparatively speaking, these works are all quite dissimilar, at least in terms of how the various photographers describe themselves. "I'm in love with everybody I've ever photographed," is for instance a maxim expounded by Larry Clark, while Vanessa Beecroft says about the women in her performances: "I do not have a relationship with the girls. ...I think of them as things for a painting." In contrast, Nan Goldin states: "I photograph directly from my life," and Sarah Lucas comments on her self-portraits: "They're less like me than a sculpture."[8]

Like Larry Clark, Nan Goldin insists on the authenticity of her photographic subjects. Both have been working for more than a quarter of a century, Clark even since 1961. They both underwent traumatic childhood experiences with which their work as photographers is at least indirectly connected. They have both adopted the narrative mode of photo-reportage. Their series can be cyclical in character or consist of selected pieces within a long-term study, or they can chronologically document events during the life of certain figures. Individual personae soon stand out in both artists' picture sequences, attracting our attention as representatives of certain roles — not unlike Proust's observations of groups of young girls.[9] But there are overriding conceptual differences: whereas Clark is preoccupied with certain outlaw figures he seeks out, Goldin documents the fortunes of friends and acquaintances. Clark obsessively assembles fragments of fringe youth culture in childhood locations *(Tulsa)* or amongst male prostitutes (42nd Street, New York), while Goldin investigates the intimate topography of the *Family of Nan,* a kind of bohemian *demi-monde,* encompassing not only sexual, but all forms of dependency. Clark collects documents of *Teenage Lust* and is interested amongst other things in a certain type of figure (the "male leader", a kind of divine youth as the incarnation of erotic promise which inevitably remains unfulfilled and frequently ends in injury or death. His pictures at times resemble dystopic counterparts of the utopian works of Elisar von Kupffer or Wilhelm von Gloeden). Goldin records the here and now of people's lives, be it the yawning abyss of death or moments of elation, funerals or marriages. Weegee and Diane Arbus could be cited as her idols. Both Goldin and Clark are interested in the borderline (erotic) character of the events they are photographing, in *the sexes and their discontents.* In her book, *The Other Side,* Goldin celebrated the life led by transsexuals and transvestites as a liberation from sexual constraint (when we got to know Misty and Jimmy Paulette we were reminded of Divine in Jean Genet's *Notre-Dame des Fleurs).* Clark takes the theme of transgression to the other extreme: he "shoots" his

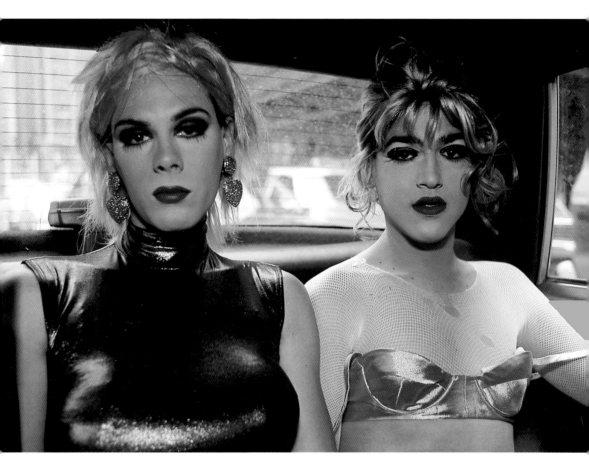

Nan Goldin, Misty and Jimmy Paulette in a taxi, NYC, 1991

objects, turning photography as a medium into a powerful metaphor for the possession of a penis — in his pictures we see people injecting heroin, being wounded by guns or erect male organs being flaunted. In this manner, the conditions for violence are also regularly documented. And in recent years, both artists have undertaken gradual changes in their artistic strategies — with controversial results: Clark shot the mass-audience film *Kids* as a moral tale, while Goldin deliberately invested pictures of models for fashion designers with the authenticity so characteristic of her well-known photo series.

Goldin has stressed that the purpose of her photo studies is not to conserve but to dispel. In particular, the *Cookie* series has shown her "how much I've lost." Fragments of a futile search for evidence, the photographs above all document the loss of, the damage to or the transgression of identity (the latter where transsexuals and transvestites are concerned). Not without reason did Nan Goldin portray herself as a victim of violence. *Nan after being battered* (1984) records the shocking results of an act of brutality against the artist. The photographic medium pitilessly registers her wounds and bruises —visible for all to see. The crucial role, however, is played by the automatic shutter release. The photographer is simultaneously positioned in front of and behind the camera — a *doppelgänger* portrait shot in the very moment of life-threatening danger. Clark's obsessive fascination for young heroes caught up in self-destruction points in the same direction. A striking feature of both artists' work is that their subjects often draw them into the action — through looks, gestures and the way their models present themselves. Sitting in the New York cab, Mary and Jimmy Paulette appear strangely fragile and arrogant, as if concealed behind a mask, yet at the same time utterly sad. How much time did they spend applying make-up and styling themselves in order to wear such a thin veil of identity over the abyss of their melancholic souls?

Vanessa Beecroft pursues disciplinary strategies of a completely different order. In art galleries and museums, the bourgeois cabinets of our

age, she has revived the spectacle which Edgar Degas once observed in the mirrored rooms of ballet studios. The uniform, multiplied figure of the concentrated dancer attempting to drill and discipline her body is the iconographic predecessor of today's model seen posing on the catwalk and in fashion magazines. Beecroft makes explicit reference to this pictorial tradition. She choreographs and dresses her protagonists in such a way that they conform to a single female archetype which, however, in spite of any idealisation strategy, never achieves pure expression — a revival of the *doppelgänger* motif, since Beecroft selects the girls according to how closely they resemble her, dressing them in costumes to "homogenise" their appearance.[10] Nonetheless, her use of multiplication introduces a sense of alienation and distance which transforms this search for identity into a labyrinthine puzzle.

Matthew Barney is also fascinated by role-playing and stresses its theatrical artificiality. Among the figures performing in his opulent dramas are fauns, satyrs, queens and idols. Barney opts for resplendently colourful costume operas, while Beecroft prefers the more frugal aesthetics of uniformity. Both switch back and forth between various levels of mediatisation; Barney operates within the art-historical iconography of the demonic and the labyrinthine and the modern mythology of sport and exercise — Beecroft, on the other hand, delves primarily into the world of fashion publishing and cinematic history. Ideally, Beecroft would like to cancel the mediatory gap between her performances and their photographic documentation, while Matthew Barney's sumptuous costume epics are in fact conceived for film projection. Besides this, Barney interweaves and combines a wide variety of role models without ever synthesising a uniform artistic identity from them. Beecroft herself never appears in her performances, while Barney nearly always does. Barney's work is remotely evocative of images in Fellini's *Satyricon* and Cocteau's *Orphée*. The artist inaugurates narrative sequences in scenarios which are highly charged with mythology, as seen in his *Cremaster* series — satyrs submerged under

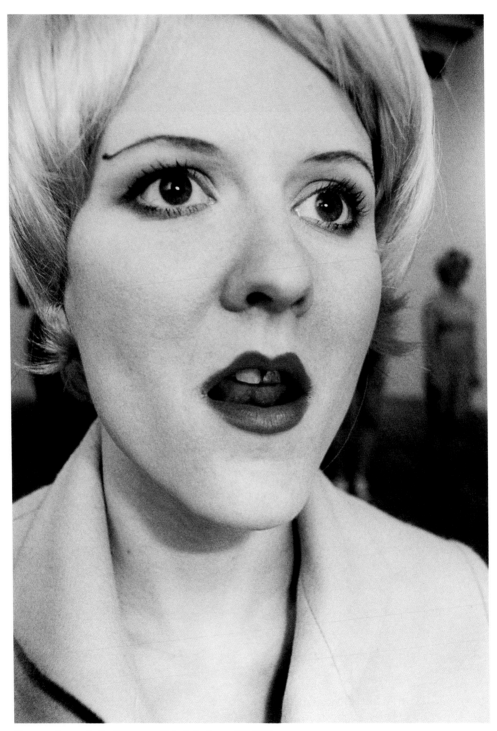

Vanessa Beecroft, Performance, Deitch Projects, NY, 1996

water, masculine contests of a bestial form, androgenic phantasmagorias, legendary characters and fabulous creatures set in oceans of flowers or magnificent palaces. Genital forms occur repeatedly, disguised as ornamental patterns—the mythical centre of Barney's fictional inventions is the utopia of a transsexual species and of auto-erotic sexual reproduction.[11] This is a disenchanted utopia, the fantasy of a melancholic devotee of eroticism. Most of Barney's videos were shot without soundtrack. Beecroft's choreographies of living sculptures are also silent, enacted by motionless and expressionless girls and staged without temporal setting. Then there is the cinematographic treatment of the *doppelgänger* topos: this all results in a hallucinatory effect, as if the artist had been trying to press the pause button on the time switch of real time. Beecroft is staging a kind of search for lost time; her polaroids and videos, the photographs and slides of her performances all resemble frozen images like those brought to the surface by memory—Proustian dream images of the "little bevy": "... if by chance I did catch sight of one or other of the girls, since they all partook of the same special essence, it was as if I had seen projected before my face in a shifting, diabolical hallucination a little of the unfriendly and yet passionately coveted dream ..."[12] For Barney, in his most recent film, the water's surface assumes the function of the gates to the underworld. The artist, akin to a modern Orpheus, descends into the world of the dead, but is reborn on the other side of the mirror. The fact that we encounter the submarine *doppelgänger* in a film, and that the events unfurl like in a dream, appears to be an allegory of the power wielded by technological media which, since their invention, have not ceased to threaten us.

Translation Matthew Partridge

[1] The author Adalbert von Chamisso speaking to his fictive *doppelgänger* in his novella *Erscheinung.*

[2] Concerning myth, I refer in the following to ideas formulated by Roland Barthes, particularly in *Mythologies.*

[3] Unmitigated extinction mythology: Oliver Wendell Holmes (1859) wanted to do entirely without living matter — the pictures were sufficient for him: "We have received the fruit of creation and do not need to concern ourselves with the core." Quoted in Wolfgang Kemp, *Theorie der Fotografie, Vol. 1, 1839–1912,* Munich 1980, p. 119. Thomas Bernhard even regards photgraphy as the "satanic art of our time," in *Auslöschung,* Frankfurt am Main 1988, p. 243.

[4] Friedrich A. Kittler, *Aufschreibesysteme 1800/1900,* Munich 1987, p. 253: "Als Metapher der Leinwand und ihrer Wirkungsästhetik."

[5] Other silent films from the First World War period featuring the *doppelgänger* motif include Paul Wegener's *Der Golem,* Paul Lindau's *Der Andere* and Wiene's *Das Kabinett des Dr. Caligari.*

[6] Roland Barthes, *Camera Lucida: Reflections on Photography,* trans. by Richard Howard, New York 1982, pp. 13–14.

[7] An example of this ambivalence between the formation and dissolution of identity can be found in Jacques Lacan's concept of the mirror stage: Lacan defines the mirror stage, the constitution of the child's identity in the face of its mirror-image, as "a transformation within the subject precipitated by the assimilation of an image" (*Écrits I*). The mirror image guarantees only a fragmentary image of the self. As Friedrich A. Kittler has noted, the media in particular "disintegrate the narcissism of one's own body schema": in *Romantik — Psychoanlayse — Film. Eine Doppel-gängergeschichte in Draculas Vermächtnis,* Leipzig 1993, pp. 81ff.

[8] Quotes from: Jutta Koether, *Larry Clark, Terminal Teenager,* in *SPEX,* 6/1991, p. 44; *Fragen an Vanessa Beecroft von Sandie Coles,* in Kunsthalle Nürnberg (ed.), *Ein Stück vom Himmel,* Nuremberg 1997, p. 47; *A Nod's as Good as a Wink,* Sarah Lucas interviewed by Carl Freedman, in *Frieze,* 6–8/1994, p. 28; Nan Goldin, *The Ballad of Sexual Dependency,* Introduction, New York 1986.

[9] Cf. Diedrich Diederichsen, *Larry Clark, Jock Sturges. Im Schatten junger Mädchenblüte — Utopie und Sexualität,* in *Texte zur Kunst,* 18/1995, pp. 65ff.

[10] Elizabeth Janus, *Openings: Vanessa Beecroft,* in *Artforum,* 5/1995, pp. 92ff.

[11] This aspect is reminiscent of motifs in the work of Hans Henny Jahn *(Fluß ohne Ufer):* Jahn also examines the motifs of bestiality and destructiveness in male love and of the ideal twin couple. Cf. Barney's series *Envelopa: Drawing Restraint 7* (1993).

[12] Marcel Proust, *In Search of Lost Time, vol. II, Within A Budding Grove,* trans. Scott Moncrieff and Terence Kilmartin, London 1996, p. 476.

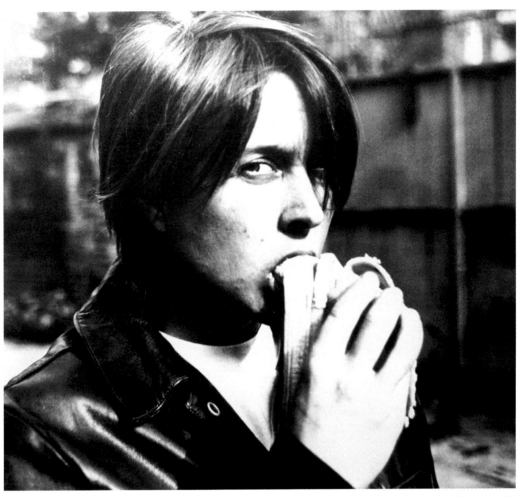

Sarah Lucas, Eating a Banana, 1990

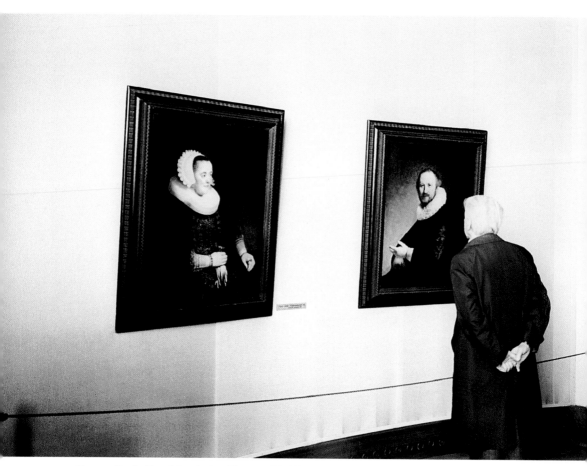

Thomas Struth, Kunsthistorisches Museum # 3, 1990

<div style="text-align: right">**Hripsimé Visser**</div>

"What Are Museums Making of Photography?"

At a gathering of photography curators in Santa Barbara, California in 1996, Carol Squiers gave a lecture titled "What Are Museums Making of Photography?" Some of the issues that she addressed were the recent disappearance of a specialized photography critic from the staff of the *New York Times;* the tendency of photographers to look anew at Old Masters as their models; the phenomenon of treating traditional techniques and processes as "new"; and the abundance of curators of modern art whose understanding of photography came mostly from its use within the context of conceptual art. This critique was reminiscent of many discussions and articles that appeared throughout the 1980s, such as a 1981 dialogue published in *October* between Ben Lifson and Abigail Solomon-Godeau that touched on subjects like a non-existent, or exclusively formalist, photography criticism, the tendency of museums to "level" all mediums by placing them under the term Art, and the significance of various photographic genres.[1] In 1982, Allan Sekula published "On the Invention of Photographic Meaning" in which he analyzed, on the basis of two famous photographs — Alfred Stieglitz's *The Steerage* and Lewis Hine's *Immigrants Going Down a Gangplank* — how photographs take on meaning through the historically established opinions about the medium as well as the status of the photographer.[2] In that same year, Christopher Phillips published in *October* "The Judgment Seat of Photography," an article that traced the modernist strategies of curators at the Museum of

Modern Art, New York, and their mission to bestow art status on photography.[3] During the latter half of the decade, Donna Schwartz, a researcher at the University of Minnesota, wrote several articles discussing the rhetoric coming from the art world and to which even photographic reportage was subjected.[4]

Interestingly, the curators who were assembled at the conference in Santa Barbara hardly reacted to Squires' sounding of the alarm. Instead, the general response was one of satisfaction that photography was at least being taken seriously by the art world. The expectations were mostly optimistic that finally an understanding of photography would grow and that even unorthodox selections or combinations of photographs with other media could place photography in unusual, but also refreshingly new, perspectives.

Anyone who looks at a list of some of the most talked about exhibitions over the past several years can only conclude that the medium is indeed being taken seriously by the art world. On further reflection, however, this would appear to be true mostly for only specific types of photography: either that based on the many variants of conceptual and post-conceptual strategies or that which looks back to more documentary impulses (in this latter case, especially to photographs that are both monumental and in color). In short, photography that conforms to artistic pretensions and usage — or those works made by an *auteur* — has no problem at all in fulfilling an essential role in discussions about contemporary art. To support this claim, one need only look at the prominent place photography was given at the 1997 Documenta, where an emphasis was given to photographs labeled "tableau" according to a newly developed theory that sees such pictures as autonomous and compares them to painterly objects made for exhibition: pictures with a historical genealogy to which only a select number of photographers belong, those who do not surrender to chance, chaos, or an all-inclusive concentration on the subject.[5]

In itself, the development of a theory is considered an important sign of a medium's coming of age. Since Alfred Stieglitz, theoreticians and photographers have taken the fine arts as a model, developing theories that were

The term "tableau" as applied to a segment of contemporary photography is certainly legitimate, but I strongly object to its use as an all-inclusive category tasting of art-historical academism.

instrumental in opening a dialogue between photography and the more classic fine arts. Each time, the dogma and the formalism to which this regularly led, was happily shattered by photographers themselves. To name only two examples: the consternation that met the "anti-aesthetic" of Robert Frank's book *The Americans* and the recent museum success that has greeted Nan Goldin's autobiographically-inspired photographs. Ironically, it is Robert Frank's romanticism as much as his subjectivity that has so firmly placed him outside the tableau model; and Nan Goldin's approach, resting as it does on the assimilation of a snapshot aesthetic, has not (or at least not yet) fallen into favor with the "academics".

The central problem for photography — and I am certainly not the first one to point this out — is content, pure and simple. A photograph is first and foremost about something. There are those photography lovers who take this fundamental truth so much to heart that they consider more transparent forms of photography, like documentary and journalistic reportage, as the only true ones; the rest is considered propaganda, as in the case of fashion and advertising photography, or art. In the final analysis, this approach is derived from an extreme type of resistance to applying concepts like "auteur," "vision," "style," and "oeuvre" to what is ultimately a mechanical medium. While I accept the value of such terms and the concepts behind them, I see their relativity as models for the whole of photography history. The term "tableau" as applied to a segment of contemporary photography is certainly legitimate, but I strongly object to its use as an all-inclusive category tasting of art-historical academism.

Andreas Gursky, Athens (Diptych), 1995

All the same, I am responsible for a collection of photography in a museum of modern art and this collection's history, its formation, and its contents are exemplary of some of the problems that are now facing those who collect photography within a museum context. Just like the Stedelijk Museum's department of applied arts, which was established in 1935, its photography collection was born (in 1959) at the initiative of the then-director, Willem Sandberg, and was modeled on the Department of Photography at the Museum of Modern Art, New York.[6] There was, as well, a group of Dutch photographers—the first generation of professional documentarists in Holland who had shown their photographs at the museum—that influenced the first acquisitions. Sandberg's rationale was simple: it did not matter whether or not photography was art but rather that the photographs purchased or shown by the museum were made by artists. During the first years of collecting, the key words were *engagement,* as in the spirit of the humanistically-oriented type of reportage photography that was prevalent at the time, and *personal vision,* a term that relativized the mechanical nature of photography and allowed the idea of an artistic calling to take hold.

It was not until the latter half of the 1970s that the museum hired a professional curator of photography and began to look at historical models for the organization of the collection. Of the two best known academic approaches to photography, that of Helmut and Alison Gernsheim and that of Beaumont Newhall, the museum's choice was the latter, preferring an art historical approach with an emphasis on aesthetics. But because the museum's finances were limited and the prices of photographs were rising, the formation of a comprehensive collection—or even the suggestion of it—was no longer possible. Nevertheless, with much love and proficiency, an exemplary collection of photographs was assembled that permits one to follow a number of major themes in 20th-century photography.

The Stedelijk Museum's photography collection functioned—and continues to function—alongside its collections of paintings and sculp-

tures, which also include photographic works of conceptual art that were acquired in bits and pieces during the 1970s and 1980s. It was only when the postmodern photographs of Cindy Sherman and Gerald Van Der Kaap were acquired during the 1980s, that a bridge was built between the two collections: a bridge that has been further reinforced by the recent phenomenon of "tableau" photography.

But behind the word "exemplary," which I have used in regards to the museum's photography collection, there lurks a problem; that is, the difficulty of presenting only one or two examples of historic photography in order to get a sense of the total œuvre of a particular photographer. One example of this are the three photographs by W. Eugene Smith that were acquired by the museum in 1987 as part of the private collection of a Dutch photographer, who had collected photography with an almost Szarkowskian sense for the aesthetic nuances of it as a visual language. One of these images is the famous "Tomoko in the Bath" from Smith's 1971 reportage on the consequences of mercury poisoning in Minamata, Japan. What does this photograph mean when it is shown in a museum? Firstly, because of its compositional structure, it is a picture that refers to the *Pietà*, an iconographic motif known throughout the Western world as a timeless, poignant but also symbolic representation of suffering and maternal love. Secondly, it is a beautiful example of the sculptural effects that a photograph can achieve through dramatic, even Rembrandtesque lighting, which in this case illuminates both bodies against a darkened background. But finally, if one pays attention to the photograph's captions, it is an isolated fragment from a reportage about the consequences of an unbridled capitalism that has no respect for anyone or anything that might get in its way. In presenting this photograph in a museum context, it is taken as an example of many early 20th-century photographers' social engagement, for example that of Weegee, Robert Capa, Leonard Freed or Koen Wessing, but it is unjustly separated from its original integrity, its context, and its narrative.

One of the most disturbing examples of the aestheticization of photography was the Magnum exhibition that toured Europe and the United States during the late 1980s.[7] In the original exhibition installation layout, the carefully selected photographs of the best-known images of post-war reportage, were placed next to one another on exclusively visual grounds in a single-minded effort to make the wealth of photographic expression clear. Later on, in another presentation, the selection was re-arranged according to many photographs' chronological and geographic contexts and several complete reportages were presented in their original, magazine layout form in order to restore the narrative intent of the pictures.

Now many photographers of all persuasions see the exhibition, the private collection, and the museum as appropriate rostrums, a pheno-menon that is encouraged by the art market and the new status photog-raphy has been accorded; and, one can deduce from photographers' chosen formats and visual strategies, that they are increasingly addressing themselves specifically to these settings. Photographs that are based on a reflection of or about "reality" are further undermined by the use of digital processes, which permit both fact and fiction to enter into a sort of St. Vitus dance. Therefore, the differing levels of meaning found in photog-raphy are being reduced — often by photographers themselves — to the purely visual, to images as fine art. Even the critical strategies of the Pictures[8] generation, who concentrated on the ways that photographic images function in society, did not result in a final deconstruction of this essentially "modernist" paradigm. One reason is that the works of such "postmodern" artists were either too illustrative or too closely allied with language as a form of visual criticism, inevitably leading to a dead end, as the recent return to painting by artists like Richard Prince demonstrates. The radical critique of images by artist and theorist, Allan Sekula, also has made way in recent years for the establishment of a position that acknowledges the aesthetic power of the purely visual.

Photography is, in the end, ultimately about images. Thus, its "survival" as a medium to which museums dedicate separate departments, ultimately depends on each photograph's visual or aesthetic merits. By insisting that Smith's "Tomoko in the Bath" be shown only in its original context, exclusively presented within the framework of the entire reportage, would be just as extreme as insisting that medieval altarpieces only be viewed in churches.

Yet, when any photographic genre is randomly shifted into the dominant "fine art" context, it sometimes will leave a dubious aftertaste. One example is the photography critic Michel Guerrin's response to the recent photography festival in Arles. In *Le Monde,* Guerrin complained about the confusion that can arise when autonomous photographs, family snapshots, archive material and photographic reportage are grouped together at a festival all under the theme of "power and its tragic consequences."[9] All photographs, no matter how gruesome and confrontational the images they present, inevitably become aesthetic; and, photographs outside of conceptual art will almost always elicit voyeuristic tendencies. There are many ways in which photography is practiced and ultimately its value, however fragile, lies in its ability to convey the kaleidoscope of ways it relates to reality.

At the same time, the recent success of photographers like Nan Goldin "proves" that, in fact, a very old-fashioned, intrinsically photographic form of narration still has its natural place in a contemporary art that is in search of tangibility, authenticity, and direct experience at all levels. It is very likely, however, that as has happened in the past, collections of Goldin's photographs will undoubtedly be reduced to a bunch of images, with her moving self-portrait, after having been beaten by a lover, seen as a radical aesthetic strategy and a symbol of all abused women.

Translation Donald Mader

[1] Ben Lifson and Abigail Solomon-Godeau, "Photophilia: A Conversation about the Photography Scene," in *October*, no. 16, 1981.

[2] Allan Sekula, "On the Invention of Photographic Meaning," in Victor Burgin (ed.), *Thinking Photography*, London and Basingstoke 1982, pp. 84–109.

[3] Christopher Philips, "The Judgement Seat of Photography," *October*, no. 22, 1982, pp. 27–63.

[4] See for example, Donna Schwartz, "On the Line: Crossing Institutional Boundaries between Photojournalism and Photographic Art," in *Visual Sociology Review*, vol. 5, no. 2, Winter 1990, pp. 22–29.

[5] See, among others, Jean François Chevrier, "Die Abenteuer der Tableau-Form in der Geschichte der Photographie/Les Aventures de la forme tableau dans l'histoire de la photographie," in *Photo-Kunst. Arbeiten aus 150 Jahren*, Stuttgart 1989, pp. 9–45 in German and pp. 97–81 in French.

[6] See Hripsimé Visser, "Introduction," in *100 Photographs from the Collection of the Stedelijk Museum, Amsterdam*, Bussum/Amsterdam 1996.

[7] The exhibition "In Our Time. The World as Seen by Magnum Photographers" began travelling in 1989 and was organized by the American Federation of Arts in collaboration with the Minneapolis Institute of the Arts.

[8] The term "Pictures" generation comes from an exhibition of the same title organized by Douglas Crimp in 1977 at Artists' Space in New York. Included were works by Troy Brauntuch, Jack Goldstein, Sherrie Levine, Robert Longo and Philip Smith. This exhibition and the texts published by Crimp in *October* were the first references to what was soon to be called "postmodern" photographic art.

[9] Michel Guerrin, "Se souvenir, culpabiliser, compatie," in *Le Monde*, July 14, 1997.

Catherine Opie, Jerome Caja, 19

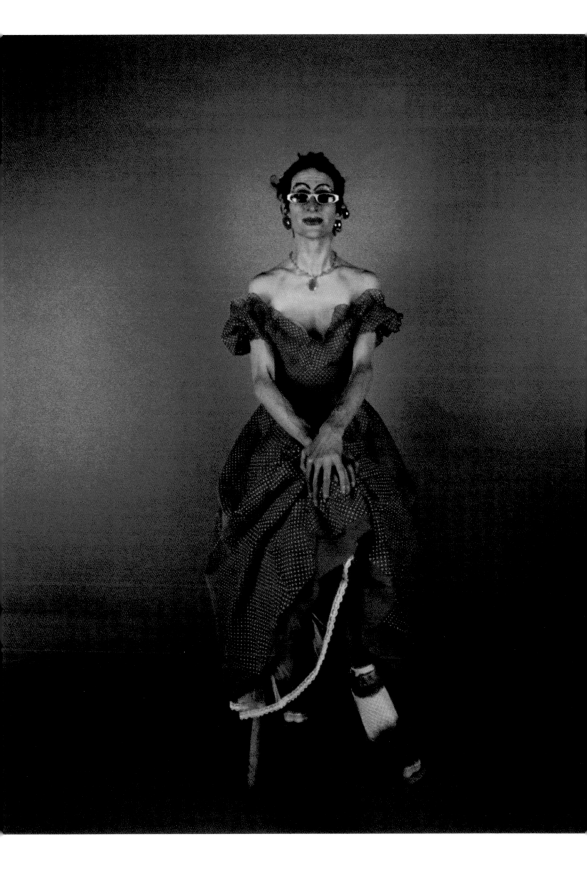

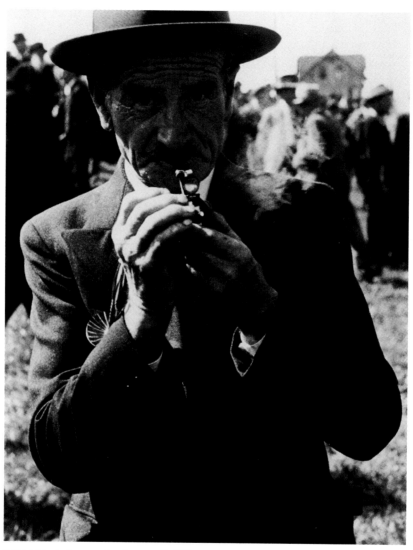

Robert Frank, Appenzeller, Appenzell, 1948

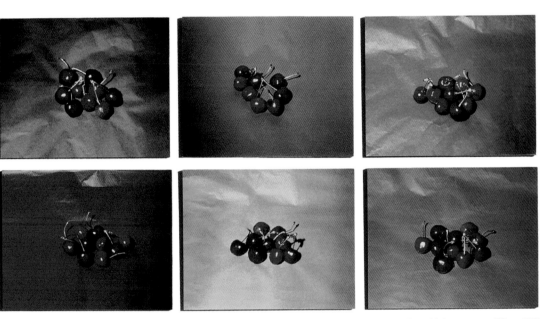

Christian Boltanski, Images modèles, 1976

Peter Fischli / David Weiss, Matterhorn, 1988/89

Neville Wakefield

Second-hand Daylight: An Aesthetics of Disappointment

Sometime in the spring of 1988, the editors of the *New York Post* dispatched a pair of photographers to New Hampshire with instructions to find J.D. Salinger and take his picture. The assignment might be seen as a report on the state of literature or more specifically on the tabloid truism that a single image is worth a thousand words. Taken in the most violent and literal sense of the word, the photograph as it eventually ran showed the sixty-nine-year-old author recoiling from the immanence of catastrophe, his features contorted into a rictus of pain and violation.

It was a sad and tragic image suggestive of the sort of "subli-mated murder" that Susan Sontag captured in the now well-worn analogy between the camera and gun. And Salinger, who had lead a life of monastic seclusion since the publication of his last short story in 1965, might have made the perfect target for such photo-voodoo theorizing of the stolen soul. But for all the talk — through Sontag, Andy Warhol and Princess Diana — of the unholy trinity of image, celebrity, and death, the picture that ran in the *Post* suggested something more than just another final act in the morality-play performed in the name of waning affect. For Salinger, and later in different ways for Thomas Pynchon and Don DeLillo, literature granted readers and authors alike a sort of diplomatic immunity from the event-life of the image. But photography of this type

breaks the apartheid of image and word. The antithesis of art-photography, it seeks to expose and develop the reality that art and literature traditionally asserts to be secret and invisible. It has become the petri dish of public culture, a place where the fray of fiction and reality has produced its own novel forms of writing in images. Where the *zeitgeist* of one era of alienation may have belonged to *The Catcher in the Rye,* that of another can be found in its shadowy afterlife, running as it did under the banner "Catcher Caught."

Art tends to begin where categories fail, and in many ways it is the failure of photography as a discretionary medium that makes it attractive to artists today. Bad photography now reigns. It has become our adult comedy action drama of ontological failure. It makes for good art at a time when good photography witnesses only the flow of technical virtuosity into addictive banality. With the demise of photographic authority and the disassociation of consciousness from that of identity, the former province of "photography" with its silver gelatin bureaucrats and legislative decrees has become something much more like a republic of photographic practice. In such a place, process is valued over product. Modes of image-making once considered to be strictly "dealer serviced" are now listed as "damage repairable" and thus up for grabs amongst non-specialists and do-it-your-selfers. The lucidity of the image-world has become detached from the old properties of "art," "editorial," "fashion," "reportage" etc. Artists deliberately flout photographic convention to follow Richard Prince's lead and practice without a license. Salinger's eventual fate at the wrong end of the long lens thus came to reflect that of photographic authority in general. The irony, not lost on younger practitioners, was that the conditions of a future literacy were to be found precisely within such a demise.

Like gossip, photography as damaged goods depends on violation. A case in point might be Sarah Lucas' black and white self-portrait of herself sucking on a banana. Aping Magritte's *Ceci n'est pas une pipe* and the whole Freudian psychoanalytics of seeing and understanding on which it is

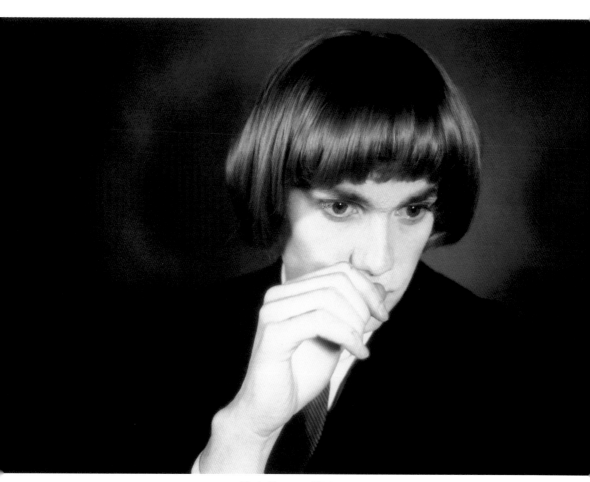

Cindy Sherman/Richard Prince, Portrait Richard Prince, 1980

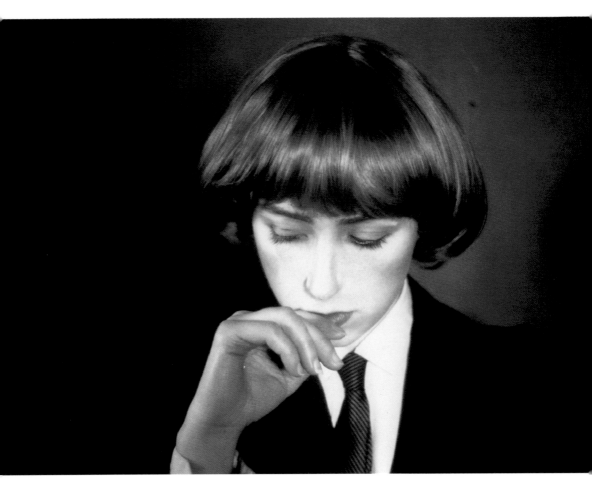
Cindy Sherman / Richard Prince, Portrait Cindy Sherman, 1980

founded, Lucas vulgarizes the dictum. Magritte's pipe may have been a painting before it was a pipe but Lucas' image presents the case for a banana being a blow-job before a photograph. The fact of its photographic circumstance is all but omitted from the argument of representation. And instead of the image acting as mirror and cool reflection, the thin surface of civility that we build for ourselves erupts outwards into a rash of the licentious and the lewdity of innuendo.

None of this is particularly new. But unlike Freud, who is said to have responded to the impertinence of a disciple who suggested that his cigar smoking constituted a phallic activity with the disclaimer that "Sometimes a good cigar is just a good cigar," Lucas refuses to let us have it both ways. And where such urges were formerly consecrated within the cannons of so-called art-photography—one thinks of Brassaï's street-walkers or Weston's nudes—it was the medium itself that was offered as alibi for the extension of the permissible through the gaze. Recently, however, such permissions have decamped from the consensus of "photography" and its claims to artiness, in order to regroup in art and its derision of photography's craftiness. Taste and tastefulness, in photography as in good cigars, is little more than a smokescreen that artists such as Lucas insist on blowing away.

The courting of vulgarity may be one way in which recent photography succeeds in shedding the prefix that held art in abeyance to technical perfection. Divested of the formal artifice that put the art in photography, cultural banality as much as natural magnificence has now fallen under the interpretive spell of the sublime. So when Peter Fischli and David Weiss make a series of airport photographs they might well be offering a pilgrim's progress—new faithful counterparts to Ansel Adams' early photographic accounts of Yosemite National Park. In both cases we come to see, and thus to enter, the rites by which figurative and literal modes of transportation meld. For Adams, the sublime vistas and high cataracts of Yosemite or Bridal Falls are rendered as recitals of natural

But for Fischli and Weiss, unlike Adams, the photograph
itself is a way of seeing rendered as strategy rather
than goal.

wonder—images of pictorial refinement all ablaze with the transportative
convictions of the photographic medium. Deadpanning the elision of
media and transport, Fischli and Weiss' airport series resolutely fail to serve
the old creed. All that we are left with are observation decks from which
there is nothing much to observe, bar the stagnant architecture of departure
gates, of jet-ways, and of second-hand air. Photography and planes alike
are grounded—their once high-flying language reduced to an Esperanto of
jet-lag and delay. But for Fischli and Weiss, unlike Adams, the photograph
itself is a way of seeing rendered as strategy rather than goal. It moves us
only to the extent that it is sublimely bad. The strict instruction to find the
fine and pretty within its own tradition is passed over in the name of hubris.
Photographic practice parlayed from the other side of this super-ego be-
comes art once again, or less portentiously, a delicious kind of informed
confusion. As the George W. S. Trow aphorism would have it: "When the
idea of winning is empty, men of integrity may fill it up. When it is full, but
empty of integrity, then the only interest is in disappointment."[1]

Perhaps more than the rest of us, artists are alive to the fact that
we enjoy a culture of embarrassment. The camera, a product of material-
istic civilization, takes inventory of our embarrassment thus giving form to
what might be called the aesthetics of disappointment. Throughout its
infancy and into its adolescence the camera was an instrument of transfor-
mation, a democratizing tool. From a material world yet to be embarrassed
by its condition of plenty, the camera effected its material alchemy. But the
transformation of substance into image also put a price on vision, since

what could be seen, could now be owned. Rarity after all, reifies the art experience. It leaves the idea of winning empty and gives form to the conviction of aesthetic integrity. Art-photography played to the gallery in a vain attempt to avoid debilitation and embarrassment. The writ of the medium inscribed in the photographic craft, acted like a small print insurance against the grand subjects inevitable fall from grace. "Good" photography's bad name has largely been upheld in the redeeming social value of its imagery — its claims to report on rather than curate the world around us. "In an initial period, Photography, in order to surprise, photographs the notable," wrote Roland Barthes of this particular phase of self-celebration, "but soon, by a familiar reversal, it decrees notable whatever it photographs. The 'anything whatever' then becomes the sophisticated acme of value."[2] Speaking to this "anything whatever" are the technical and apparently aesthetic deficiencies of recent practice. With the aesthetics of disappointment, the big picture may be gone forever.

 As an example of this, Alfred Stieglitz and Richard Prince both took pictures of their girlfriends — albeit that the take of one comes from the light of day and that of the other from the pages of a magazine. Stieglitz's most famous girlfriend photograph is a picture taken in 1919 of Georgia O'Keeffe. It has been described as a image worthy of Phidias, a sublime compound of tradition refracted in the photographers' art. Finessing the body beautiful, Stieglitz's lens asserts power over it and its traditions. Prince's girlfriends offer none of that. One of them, naked except for sunglasses and tattoos, bears an open leg wound to the camera. Broken across the gully of a magazine it is an image held together not by the play of light but by the binding staples suggested in the steel embrace of the biker chick's fractured shin. Disturbed into a sort of proud incoherence, Prince strip-mines photographic convention exposing the pictorial underbelly and the scars of its raw material. When the artist shoots the photography sheriff, Phidias moves to the page of *Outlaw Biker.*

Such a comparison might provoke a number of prognoses re-
garding the state of photography, if not the state of relationships. Analyzing
the images and respective practices from which they are born, it is easy
to find in them symptoms of health and disrepair. To many, Stieglitz's photo-
graph of O'Keeffe is "healthy" in a way that Prince's "girlfriends" are not.
After all, its cultivation of ideal form takes place within the grand narratives
of that tradition. It has yet to be tainted by the sort of decadent, unhealthy
amateurism celebrated in the "readers-wives," "girlfriend" and "pet"
pages of biker and other such magazines. But certainly it could be argued
that just the reverse is true — that the photographer who seeks legitimiza-
tion within the grand traditions of photography relinquishes the hope of
having a share in the public culture of his or her time. For the present
generation, the waking dream has become an air-brushed nightmare and
damaged flesh is all that we have. And if the enthusiasms of disappoint-
ment are the true heirs to a banished tradition, bad photography may well
be our only hope — a ruination enclosing the last legitimate attempt to
form an aristocracy.

[1] George W. S. Trow, "Within the Context of No Context," in *Atlantic Monthly Press*, 1997, p.34.

[2] Roland Barthes, *Camera Lucida*, Fontana, 1984, p.34.

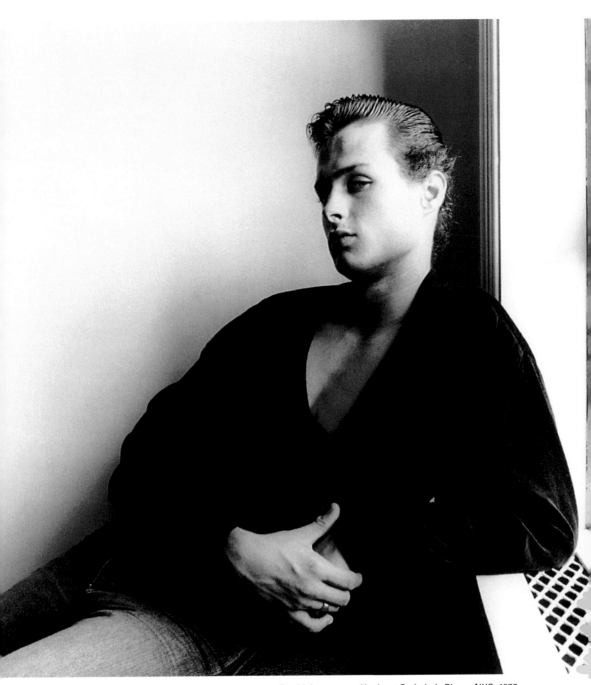

David Armstrong, Kevin at St. Luke's Place, NYC, 1977

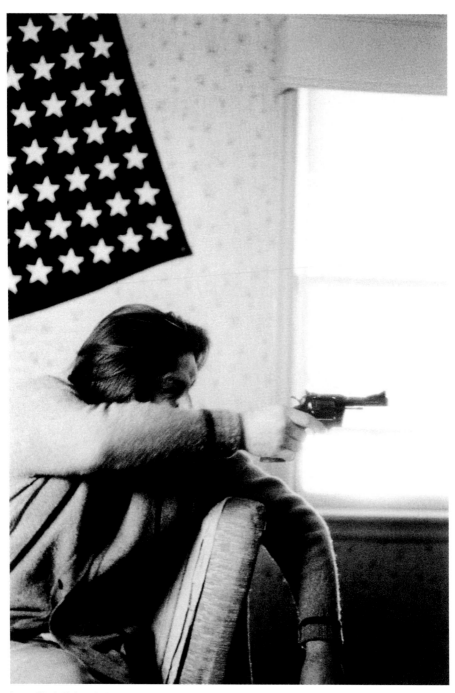

Larry Clark, Tulsa 1968–71, 1972

Jeff Wall, An Octopus, 1990

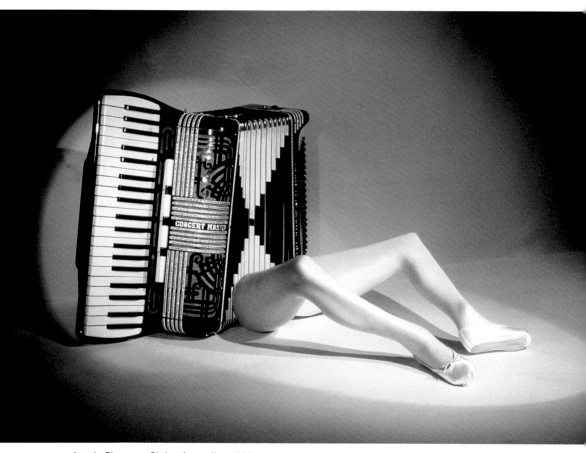

Laurie Simmons, Sitting Accordion, 1992

Günther Förg, Villa Malaparte, 19

Günther Förg, Bauhaus, 1991

Jean-Luc Mylane, No. 30, August, September, 1981

Christopher Wool, Untitled, 1992

DATE DUE

NOV 0 1 2001			
MAY - 5 2005			
GAYLORD			PRINTED IN U.S.A.